A Woodcarver's Workbook

Carving Animals

with

Mary Duke Guldan

by Mary Duke Guldan

Second Edition

Fox Chapel Publishing
Box 7948B
Lancaster, PA
17604

Published by Fox Chapel Publishing

Cover Design: Brian S. Reese

International Standard Book Number #1-56523-033-7

To order more copies of this book,
please send cover price plus $2.50 for postage to:
Fox Chapel Publishing
Box 7948B
Lancaster. PA 17604

Try your favorite bookseller first!

Manufactured in the United States of America
92 93 94 95 96 1 2 3 4 5 6

Dedicated
to my teachers;
John A. Guldan,
William Wheeler (in memoriam)
and Gloria Randolph Guldan,
as well as
Edward Gallenstein
who launched this book

Table of Contents

Foreword and Safety Tips 1

Carving Basics 2
Basic Tools
Making the most from your patterns

Cougar 7
Step-by-step carving seminar
Laminating projects illustrated

Cottontail Rabbit 22
Detailed techniques: carving ears

Wolf 29
Detailed techniques: carving fur

Pointer Dog 33
Detailed techniques: using patterns to carve a relief project

Bighorn Ram 38
Detailed techniques: spiraled horns

Whitetail Buck 44
Detailed techniques: carving and adding antlers

**Mustang Horse
and Unicorn** 52
Detailed techniques: carving nostrils

Moose 62
Detailed techniques: antlers and hooves

Finishing your Carving 72
Painting, Staining and Sealing Techniques

Building Displays and Bases 81

FORWARD!

For those who never read 'em....

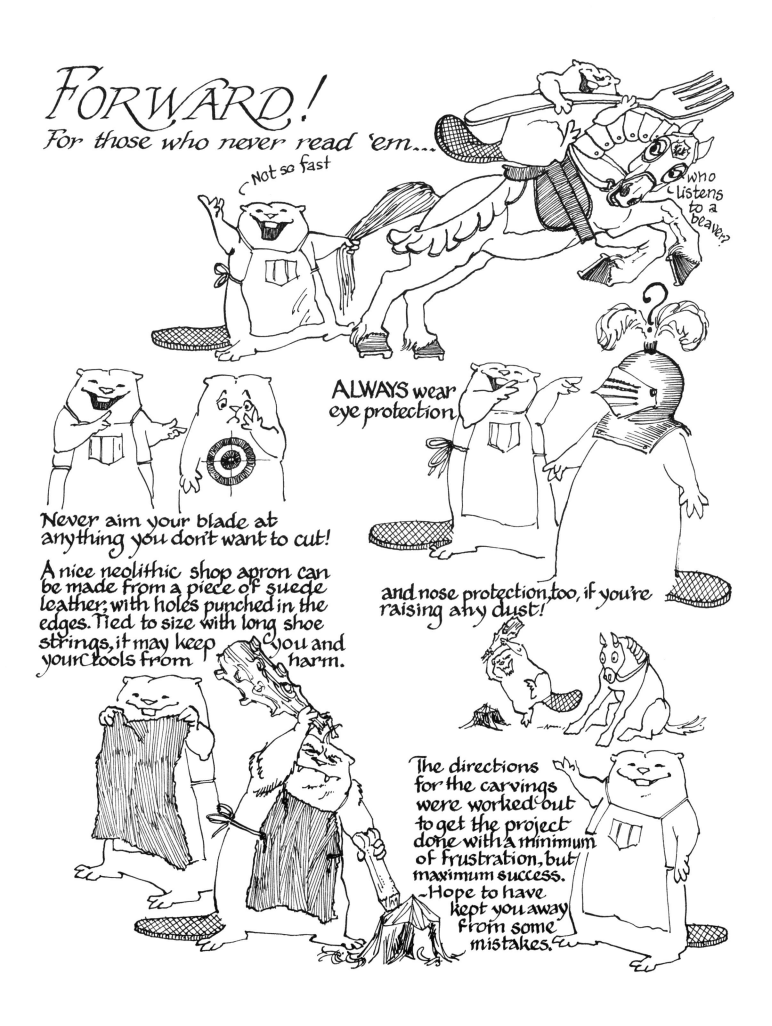

— Not so fast

who Listens to a beaver?

ALWAYS wear eye protection

Never aim your blade at anything you don't want to cut!

A nice neolithic shop apron can be made from a piece of suede leather, with holes punched in the edges. Tied to size with long shoe strings, it may keep you and your tools from harm.

and nose protection, too, if you're raising any dust!

The directions for the carvings were worked out to get the project done with a minimum of frustration, but maximum success. — Hope to have kept you away from some mistakes.

How to Make the Most from Patterns

LET's get right to work! These patterns can be the basis for a variety of projects. The most obvious application is to assist your carving free-standing, three-dimensional figures to enjoy as sculpture.

With the addition of a suitable background, any of the pattern views can be carved in relief. Eyecatching variety can be achieved by omitting a scenic background, sawing the profile from a thin slab of an exotic hardwood, modeling it with restraint and applying it to a contrasting, though untextured panel. This is especially handsome when used as architectural ornament on a chimney breast below the mantel, on cabinet doors, the crown of a bookcase, the back of a gun rack. With an appropriate foliate border the animal figures in relief can be the center piece for an extravagant crown moulding over a full-length mirror, above a door or on a window valance.

You may prefer to do just a detailed head study, which, if small enough, can be a highly individualized personal ornament when used on a pin, or bolo tie, or as a pendant.

If you are really adventurous and ambitious with a small, fine bladed saw, like a jeweler's saw, you will find that you can saw miniature profiles which can be shaped with flies or burrs and abrasives in a flexible shaft grinder. Besides the colorful hardwoods sold for marquetry and inlay, you'll find that some seashells have suitable areas which can be ground flat on the back and used cameo fashion, epoxied to a contrasting hardwood. Abalone can be cut and shaped into components for jewelry this way.

Decide how your finished carving is to be used in order to select the most effective wood. For practice pieces, basswood (linden) is an especially forgiving choice. Its grain is not as determinedly directional as most, so will allow you to cut more freely. It absorbs paint or stains readily and accepts a wide variety of finishes.

Show or market pieces carved from a colorful hardwood like mahogany or walnut are impressive and appealing to judges and collectors, who often admire the character of the wood as well as the figure you've sculpted. Adjust your pattern to take advantage of the most dramatic grain, because it will emphasize the direction and dynamism of your figure.

Along with this advice, do exercise caution. Check and double check for soundness before you even try a pattern on that piece of wood, as "loud" figure may occasionally indicate some long forgotten climatic trauma, fungus or insect attack on the tree's then living tissue, resulting in a weak place. I once designed a leaping whitetail buck around a rich, sinuous pattern in a piece of stock. It looked the essence of the crackling tension in his bunched muscles, and required quite some maneuvering to take advantage of as much of it as possible.

Only as I was finishing did that grain's true character surface, when I brushed a hind leg that became unnervingly flexible!

Along that splendid stripe the wood fibers were separating like the pages of a book!

There is a happy ending to the story. Only the pair of legs on one side had to have painstaking "reconstructive surgery," involving each layer being split off cleanly with a razor blade and reassembled with epoxy and a reinforcement rod up the center. The buck showed well, and his "scars" were invisible.

Depending on the extent of your experience and the species available in your area, you may have a favorite wood. By all means, use it.

The same is true for your equipment. Use the equipment and techniques which net the results you want. The tools to which the text refers are illustrated so that your choices can approximate them in shape, size and function.

In order to finish up with a fine carving, one must begin with the most accurate pattern possible.

Far superior to tracing paper is the transparent acetate plastic now available by the sheet or foot at many artists' or office supply stores, or blueprint materials firms. You may find the clear sheets which fit into removable plastic spines sold to cover students' papers work just as well, or you may improvise by stretching and taping clear plastic food-wrap over a cardboard "window" frame.

Through the acetate, every detail of the drawing is clearly visible, and is easily traced. The outline of the drawing, including any of the cutting lines for asymmetrical sides is transferred onto the plastic in permanent felt-tip marking pens, which will not run or bead and cause problems later.

A sheet of paper is placed over the acetate tracing; by holding these against the glass of a window or stormdoor backlit by sunshine, you can trace your pattern onto the paper. The pose can be adjusted somewhat by moving the acetate underneath your paper.

A tour of the tools mentioned in the text...

All of your carving can be done with a small standard carving tool set, which usually includes the following:

| chisel - stop 'cuts around reliefs, surfacing

| bent chisel - especially for relief backgrounds

/ skew chisel - reaches in between animal legs, tails

V 'v' tool - creases and wrinkles, hair texturing

) shallow gouge - does basic shaping, surfacing

) deep gouge - muscle definition, eyes, hair

These are about 6½ inches long; choose oblong wooden handles (rather than mushroom-shaped 'palm' handles) for maneuverability.

a mallet powers your cutting edge, gives finer control

a 'bench' knife, if you don't have a pocket knife for 'whittling' details

a fullsized shallow fishtail gouge
½ inch wide blade

This gouge can 'rough out,' splitting off a lot of waste. The fishtail shape allows it to reach into 'corners' and tight spots. It makes a shallow, faceted cut, that can be an effective, attractive surface.

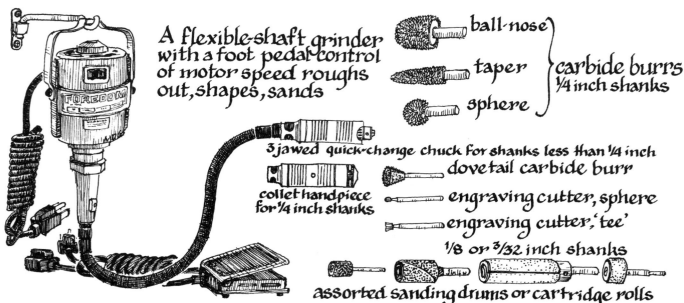

A flexible-shaft grinder with a foot pedal control of motor speed roughs out, shapes, sands

ball-nose

taper

sphere

carbide burrs
¼ inch shanks

3 jawed quick-change chuck for shanks less than ¼ inch

dovetail carbide burr

collet handpiece
for ¼ inch shanks

engraving cutter, sphere

engraving cutter, 'tee'

⅛ or 3/32 inch shanks

assorted sanding drums or cartridge rolls

Using acetate is especially effective when the design is to be carved as a relief, rather than a three-dimensional figure. If you are not particularly confident in sketching in any appropriate landscape freehand, trace one onto acetate from a wildlife, nature or hunting magazine photograph. This can be moved into position behind your paper pattern and is easily repositioned for the best effect before you trace it into place around the animal figure you've already drawn on the paper.

Tracings on acetate are very durable and can be used any number of times. It is not advisable to trace them or the pages of a book or magazine with carbon paper underneath because the furrow left by the point of the pen or pencil is damaging to both acetate and printed page and may cause them to tear later.

When you plan to enlarge a pattern, you might first check into the services offered by a quick-print copy shop, if there is one in your area. Some of the more sophisticated xerographic office copies have enlargement capabilities, so that by copying each copy of your pattern at a larger setting, you can magnify it to suit your requirements.

If these services are unavailable, you can always rely on the ancient technique of transferral by enclosing the original in a grid of small squares and redrawing it, square by square in the bigger boxes of the proposed enlargement.

For three-dimensional projects, mark (both) the left side leg(s) then cut around the outline edge of the working paper pattern; this will enable you to position it more easily on the wood, dodging possible flaws.

Now, let's put this pattern to use!

Laminating, or gluing together layers of lumber to get the suitable thickness is recommended. If you saw out only what the project requires, minimal wood and carving time are lost in waste removal. The drawing of numbered layers included in each set of plans refer to these pieces.

Besides being more easily cut, lumber is more readily available than blocks for carving, and is in many instances, much less expensive because so little of it will end up in shavings. Often, when shopping for "exotics," you will find only boards and no blocks at your suppliers.'

Because wood was once living tissue, responding constantly to the stresses of its environment, that block may harbor all kinds of dark secrets in its interior. Inevitably, if there is a knot or imperfect grain, it will only occur in a slender, fragile, weight-bearing leg!

For this reason, from Renaissance times, European sculptors have envisioned their masterworks in less capricious marble and more malleable bronze.

Flaws in lumber are usually apparent from one side or the other and can be avoided.

When properly glued, lumber is less likely to check, or crack due to changes in atmospheric humidity or heat than a block of similar proportions.

In deciding how to best use the wood of your choice, shave a sliver off one lengthwise edge, first from bottom toward the top, then reverse direction. The way in which you cut the wood and found it least inclined to splinter, break or crumble is your primary grain direction and is best employed running from the bottom of your project, toward the top. This may not be a pronounced preference in basswood, but in most other species it makes a most decided difference, especially if you use cutting, rather than grinding tools at any point in your project.

Using a pencil, begin tracing around the edge of your pattern, referring to the plans to avoid drawing in what will not be actually required, like extra layers of head for example.

Where the position of one part is obscured by the pose of another, you might trace the necessary guidelines with a dressmaker's pattern wheel, whose little points will dent the wood slightly, and can be penciled in afterward. You can bruise the wood with a poke of your sharp pencil point, and thus make your own row of little guide-dents right through the pattern.

Another possible advantage of laminating lumber for your blank is that you need not have access to a bandsaw to cut out your material.

Your pieces can be sawed out by hand with a coping saw. The same type of saw with a deeper frame may be called a scroll or fret saw and will allow access to more of the interior of your lumber.

For miniature work, especially involving the extremely hard exotics, like ebony, a jeweler's saw is essential. It looks like a small coping saw, but with screw clamps to hold the blade, which has no pin ends. Jeweler's saws are available through some of the more comprehensive tool suppliers for models making and hobbies involving metal or hard plastics.

I enjoy the luxury of cutting blanks on a treadle fret-saw fitted with jeweler's saw blades. Because the blades are so small they cut a kerf no wider than a pencil line, so I am able to cut the exact outside profile of a piece, reducing waste to an absolute minimum.

A jigsaw or power driven scroll saw will cut out your blanks in short order.

If your lumber is not wide enough to accommodate the full length of your pattern, you can effectively piece together the sections by dividing each layer across the barrel or torso into "head" and "tail" pieces, staggering the glue joints. Use the squared edges of the lumber for the dividing line, folding the paper pattern exactly over that edge as you trace the "head" end, so that you will know specifically where to begin the corresponding "tail" end. Make sure all the pieces are going the same grain direction!

Pencil in the identifying layer number on each piece immediately, so that while they need not be sawed out in numerical order, they can be assembled correctly!

Test for correct fit in a "dry run" before you begin gluing.

For figures of this size and decorative purpose, aliphatic resin, or yellow carpenter's glue has proven most durable and satisfactory.

Spread it generously on the contact surface of the first piece; an artist's flexible steel palette knife used in mixing oil paints is most helpful in getting even coverage.

Position the second layer on the first, edge gluing any divided pieces and aligning exactly.

Tack the layers together in at least two places to prevent slippage when the clamps are tightened.

The small nails you use in tacking need to be long enough to go through one layer of wood and into the next at least a quarter of an inch. They should be as skinny as is possible to drive without bending, yet with enough of a head for you to grasp to remove them.

Apiary (beekeepers) suppliers sell wire nails used in building honeycomb frames that suit our purpose excellently.

Apply clamps, using as many as needed, especially on extremities, carefully checking against any shift of position.

Scraping off the bead of glue which wells up at the seam may help the interior set faster.

Once the glue has set (check manufacturer's recommendations on the glue container—with aliphatic resin, usually an hour) gently remove the nails, then take off the clamps. Spread glue on the second surface and position the third layer on it, again, tacking the new layer in at least two places per piece. Reapply the clamps.

Continue the setting time, then gently remove the nails, followed by the clamps. Repeat the glue-tack-clamp procedure with the next layer.

Build your blank layer by layer this way until the required thickness is attained. When the final layer has been applied, give your blank overnight curing time with the clamps still in place.

Your blank should be ready to use the next morning just as soon as you remove your final tacking nails and the clamps.

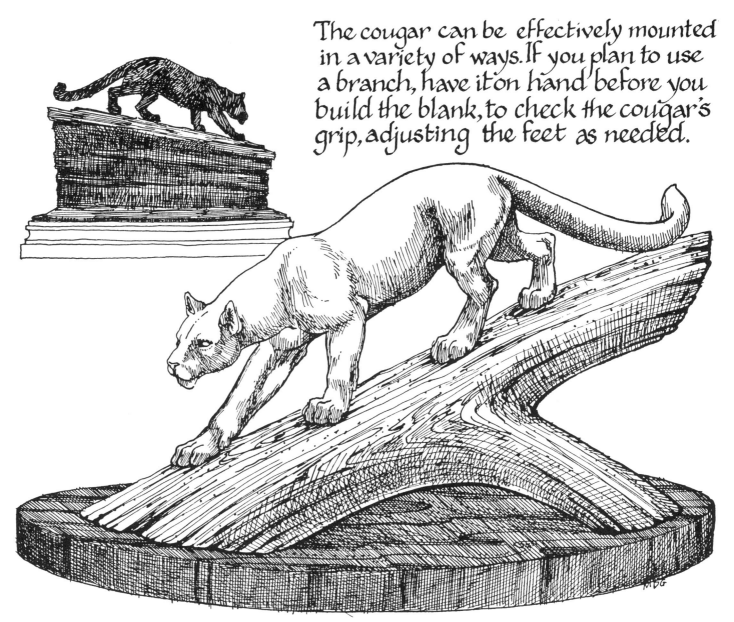

The cougar can be effectively mounted in a variety of ways. If you plan to use a branch, have it on hand before you build the blank, to check the cougar's grip, adjusting the feet as needed.

COUGAR

FELIS concolor, variously called puma, panther, mountain lion or cougar, is North America's largest native cat. It is a single-minded, efficient stalker, stealthily approaching its prey until it is within striking range, usually felling the large animals by leaping onto their backs. Like many other "big" cats, the cougar is capable of a considerable burst of speed over a short distance, is a superb climber and an occasional swimmer, under duress.

This cougar will serve as a demonstration piece, with the blank construction and carving detailed step-by-step. These same techniques will be used on subsequent projects, as the procedure of starting on the rump and back, working forward, trunk and neck, then legs and head, is a practical way to prevent breakage of frail appendages while maintaining awareness of the relationships of all parts to the whole.

If you envision your carving mounted on a weathered "deadfall," it would be well to have the intended piece of wood on hand ahead of time so that you can check your pattern's fit to it, adjusting the position of the feet where needed, before you make up your blank.

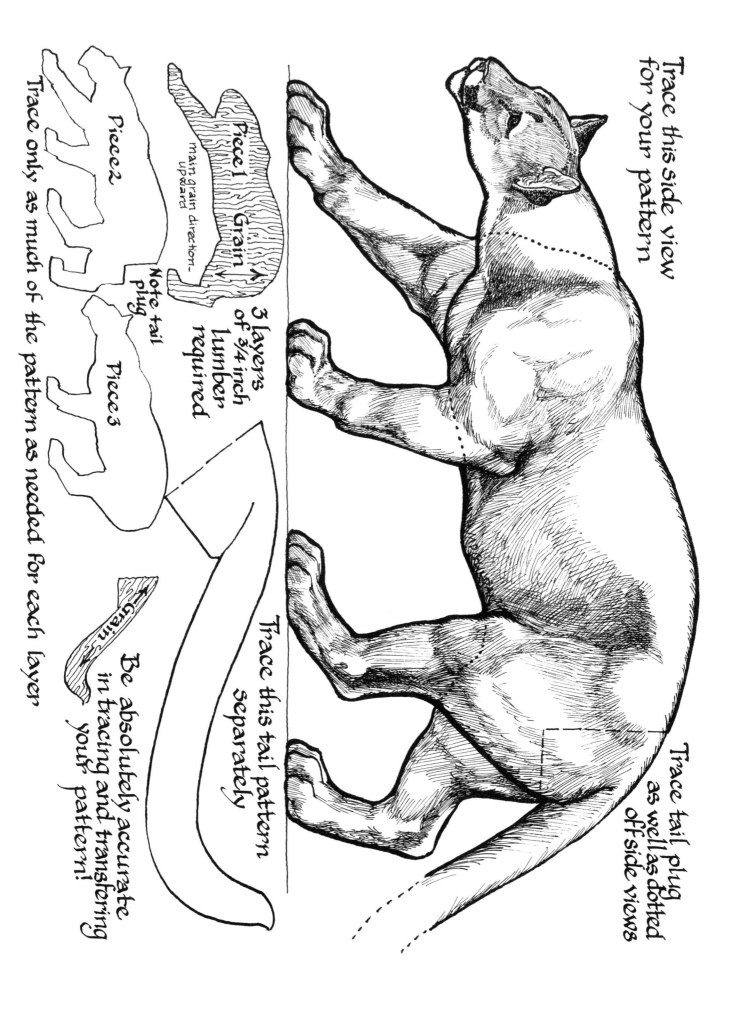

Trace this side view
for your pattern

Trace tail plug
as well as dotted
off side views

3 layers
of 3/4 inch
lumber
required

Piece 1 Grain

main grain direction—
upward

Note tail
plug

Piece 2

Piece 3

Trace only as much of the pattern as needed for each layer

Trace this tail pattern
separately

Grain

Be absolutely accurate
in tracing and transfering
your pattern!

1. Trace your pattern on clear acetate, or clear/frosted acetate ~ frosty side up, using permanent marker.

2. Transfer the pattern from plastic to paper by holding the acetate against the glass of a large window or door. Put your paper over the acetate and trace your working pattern. By moving the acetate under the paper, changes of pose can be tried.

3. Using the lamination layers in the book as a guide, number legs, head, appendages on your pattern, layer by layer.

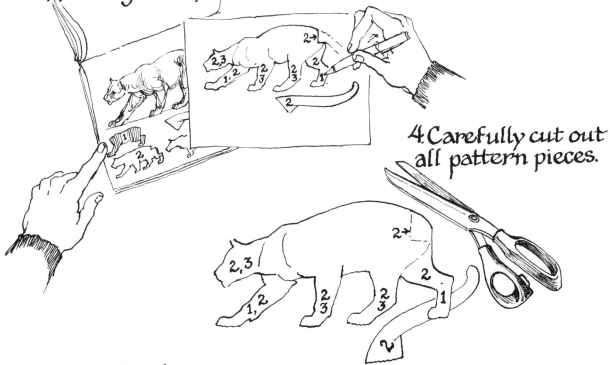

4. Carefully cut out all pattern pieces.

5. Select your lumber.
Your acetate tracing can help you dodge flaws or check grain. What if your lumber isn't wide enough? No problem.
We'll splice.

OOPS!

Here's the way...

Plan on dividing the figure through its trunk, using the edges of the lumber to butt-join, because they are straight.

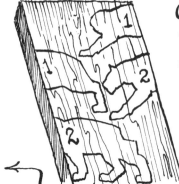

Crease the pattern over the edge of the board and number each side of the line as well as each piece on the board as soon as it is traced.

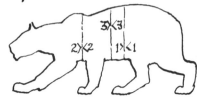

Stagger the joints. Don't halve a head or leg.

All divisions must 'head' the same direction.

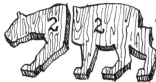 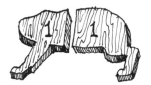 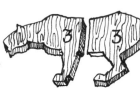

Take a 'dry run' with your cut-out pieces.

Stack them up in assembly order to check alignment and fit.

Edge-glue both sides of layer 1.
 Edge-glue both sides of #2.
 Glue layer 2 on top
 of layer 1.
 If you are inclined to break
 things, leave the tail off.

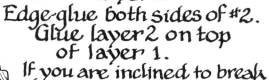

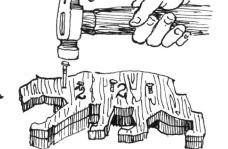

(In hardwoods, you may need to drill a little pilot hole for the wire nail to prevent its bending.)

Drive a couple of wire nails in each piece of the top layer to prevent squirming when you apply clamps.

If possible, clamp each extremity being glued, as well as the trunk.

When the glue has 'set' gently remove wire nails, then clamps.

Glue, then tack and clamp layer 3 on top of layer 2. Let glue 'set.'

After the last layer is applied, allow the blank to dry over night before removing the nails and clamps.

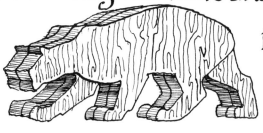

Now you've got a blank ready to use.

Let's carve!

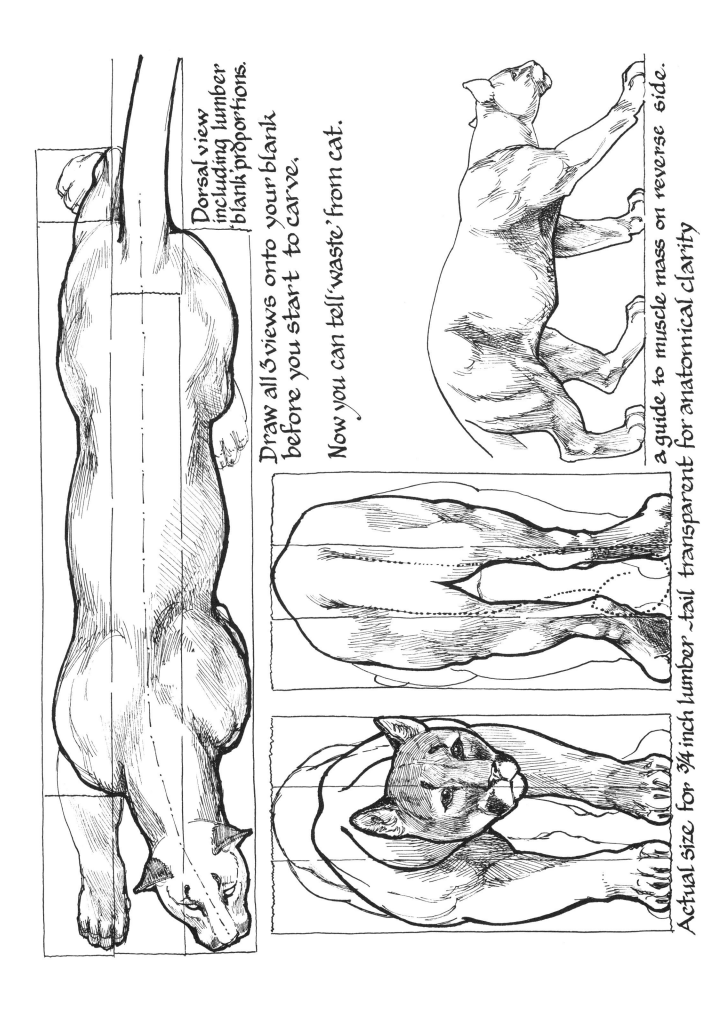

Dorsal view including lumber 'blank' proportions.

Draw all 3 views onto your blank before you start to carve.

Now you can tell 'waste' from cat.

a guide to muscle mass on reverse side.

transparent for anatomical clarity

Actual size for ¾ inch lumber — tail

Draw front, rear and dorsal views on your blank. A centerline, approximating the animal's backbone is very helpful. Cross it with a line where the eyes will be to establish face direction.

If you plan to rough out with mallet and your largest gouge, the piece must be secured to your bench.

Always clamp on trunk, never on head/neck or legs.

A 'benchdog' fits through a hole in the bench. piece is caught between 'dog and clamp.

If you rough out with a flexible shaft grinder, you will need a nonskid, non-snag work surface—like a car floor mat, or scrap of heavy upholstery leather. The piece need not be clamped to your bench.

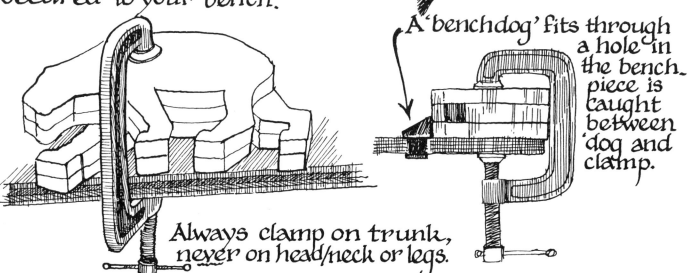

1. Starting with your largest gouge or carbide ballnose burr, working from rump toward shoulder, take the edges off the blank, establishing the tentshaped peak of the backbone. On your second pass, start a little lower, again working from the rump, forward. Your centerline should be intact; check your back view to see how much waste you have yet to remove. From the hind 'knee' bulge*you will be working bottom toward top, back toward front.

If you are working with gouge and mallet, you will likely continue roughing out the whole side, shifting your clamp, with a pad of folded felt or leather protecting the wood, now.

When working with the grinder, carve on one side, then the other, comparing them to each other and the charts~ continuously!

At this point, you should have established the main planes in back.

2. Now turn your attention to the back edge of the bulge of shoulder muscle~ pencil it onto your blank. Starting on the ribcage in back of that muscle, working from bottom to top, carve the barrel.
Next, carve from the widest curve of the ribs down toward the belly. Pencil in the 'knee' position so that you will know where to stop*

Check your progress against the dorsal view diagram. Note the way the ribs spring out where they no longer accomodate forearm motion/muscle. The body narrows at the end of the ribs where viscera sags into the sling formed by abdominal muscles.

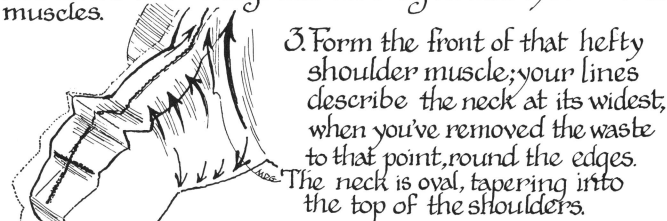

3. Form the front of that hefty shoulder muscle; your lines describe the neck at its widest, when you've removed the waste to that point, round the edges. The neck is oval, tapering into the top of the shoulders.

When you've removed enough of the waste from either side of the face to give it a slightly leftward focus~ leave it rough for the time.

4. Let's go to work on the feet and legs. Draw a circle on the sole of the 'blank' foot to approximate the size and location of the foot.

Blank is much enlarged to show detail.

For grinding, you may find control easier if the back of the wrist holding the tool is braced on the edge of the bench. The carving is rotated.

For mallet and gouge work, the piece must be firmly anchored, even when your mallet is tapping very gently. Folded felt or leather padding under the piece, between it and the bench, and between it and the clamp(s) will prevent bruising (crushing) the carving. Getting the piece secured safely can be very challenging (~frustrating... aggravating...)!

Having established the location of the feet, now remove the waste from either side of each leg.

Your fishtail gouge can do all but the insides of upper legs, best tackled with your smallest gouge. Folds and skin creases are defined with the 'v' tool.

When grinding, you'll find that your biggest ballnose burr shapes and models the outsides of the legs, but you will want to switch to a taper to do the insides of those rascals.

By this time the only square edges left are those on the head.

A Blockhead?

A WOODCARVER'S WORKBOOK

5. So, let's get that head shaped up, taking off very little waste at a time, because every little chip makes such a difference in the facial expression.

First round off the forehead and jowls; do try to avoid cutting toward the ears, or into their bases. Next, round the top of the muzzle. The muzzle is smaller in diameter than the forehead, and ends in a bit of a point at the chin. Use the fishtail gouge or taper burr.

Switching to a smaller gouge or dovetail burr, develop the hollows for the eyes, then carve the slight edges on either side of the bridge of the nose, coming round to a little point in the center front of the muzzle.

Gently form the faint depression where the lips meet, following the puffy muzzle shape around to the cheek.

Draw on the ears and forehead centerline.

Start small cuts toward each other with fishtail gouge or taper burr until head level is reached. While there is still waste on the backs of the ears, work on the tufts of hair inside the ears, with you smallest gouge and 'v' tool, or taper's tip, along with a tiny round engraving burr.

Hollow along the edge of this tuft to approximate the widening opening to the ear cavity, then leave the ears, braced by waste, while you detail facial features, if that is your preference.

If your wood is strikingly colored or grained, you may choose to omit the detailing in order to concentrate on sculptural planes highlighting the exotic character of your medium.

The features would be simplified, minimal.

6. Carefully pencil in the location of the eyes, noting their triangular, not oval character.

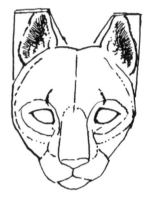

It's best to draw a few practice eyes on scrap lumber to hone your skills. Carve these to 'warm up'; you can use this routine, with variations for eyes of all kinds.

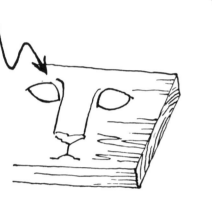

First, use a gouge with the size blade and curve corresponding to the portion of eye on which you are working~ tiny for cut #1, slightly larger for #2 and 3.

On a practice plank, secure the piece so that, for the first time or two, you can use both hands to control the tool until the process is more familiar.

For this operation on an actual piece, you'll do best to hold the carving securely on your nonskid surface with one hand, wielding the tool with the other. Each can aid the blade action.

Now~for the cuts ~

Plant your blade here, concentrating on getting it exactly in the tearduct* eye-corner, curve toward eye. The cut should angle slightly under the lid.
When you have pushed the blade in, establishing a firm 'stop cut,' rock the blade corner down to cut deeper into the duct corner.

left eye *

Next, plant your blade in eye corner #2, again angling the cut slightly under the eye lid.
Once the 'stop cut' is made, rock the blade corner toward the outside eye corner, deepening that portion of the cut.

The bottom of the eye is more of the same, only rock the blade into both corners, this time.

Holding the little gouge you used for cuts #2 and 3 on a shallow angle, so that the curve of its blade forms the spherical eyeball, cut toward the inner eye corner. Make sure to push into your stop cut firmly enough to shear the chip cleanly.

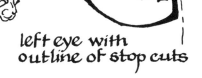

left eye with outline of stop cuts

1.

Cut next toward the outside eye corner. The corners are cut deeper, remember, to be proper lids opening over rounded eyeballs.

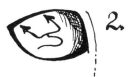

2.

Now, finish the eyeball-shaping with cuts from center toward corners to round that lower portion.

3.

With the bench knife, cut a chip out of the inner eye lid corner, in two strokes.

Make a similar, though more shallow cut to form the eyelid crease at the outer edge.

Use your tiny gouge, very gently, to indicate eyelids and eye sockets.

(Tools not to scale)

1.a,b. With fishtail gouge make a little depression for eyebrows.
While that gouge is handy, refine the faint furrow up the center of the face.

2. Little gouge cuts small slot from nostril (a tiny triangular chip removed with point of bench knife). Slot stops at corner.

3a,b., Lips should be pencil planned; 'stop cut,' from corners to center, is angled up a little, as bench knife. Fishtail gouge cuts up and in, making an

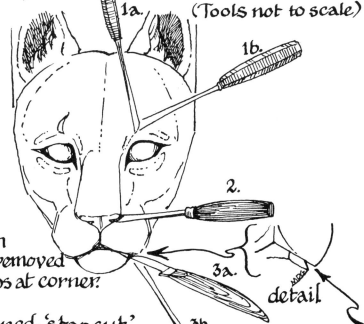

detail

well as in, with angled 'shelf.'

7. The paws are ready for detailing now. Pencil in the location of each toe, noting that there are 4 toes on each foot, but there is an additional 'dewclaw raised inside each fore foot. The toes should be a bit wider bottom than top to accommodate retractile claws.

← inside

Use your 'v' tool to establish the line where the toes meet in 3 short upward scooping strokes simulating knuckle joints.

1.

2.

3.

not to scale

Use 3 strokes on the dewclaw; note #1 stroke is reversed, if possible.

Now go back with your small gouge to do the actual modeling. Turn the blade sideways to form the toe pads.

Refine the edges of each toe joint, next.

Level the foot to undercut the dew claw a bit.

1. 2.

1. 2.

Use your smallest gouge to add just a hint of the metacarpals showing above the toes, below the 'wrist' on

If you find you need a stronger shadow to reinforce the kind of poised power implied, poke the bench knife in between these upper joints.

Carved claw sheaths won't be needed on this scale, though this is where they'd be.

8. Before getting too involved in muscle definition, we will glue the tail in its socket.

A stout rubber band twisted around the tail and some projecting point is usually clamp enough. Let dry thoroughly.

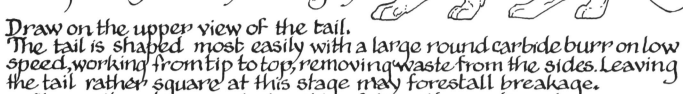

Draw on the upper view of the tail.
The tail is shaped most easily with a large round carbide burr on low speed, working from tip to top, removing waste from the sides. Leaving the tail rather square at this stage may forestall breakage.
It can then be rounded quite safely with sanding drums.
To keep the tail from looking too much like a snake or a squash, texture it with a few cuts of your smallest gouge, followed by the 'v' tool.

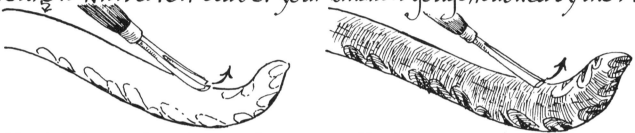

9. Model the tail root into the rump: the large round carbide burr will fit this area well, without endangering neighboring musculature.

10. Only if your piece is of a colorful or dramatically grained hardwood is the carving most effective when sanded off absolutely slick. Otherwise, the gloss causes distracting highlights.
The most successful finish for most carvings is a lightly faceted surface from a very shallow gouge (your fishtail), with only limited sanding to highlight the topside of convex, often muscular areas. The smallest gouge refines joints and muscle mass.
Last, gently remove the supporting waste from behind the fragile ears. This can be done safely by sanding drum.

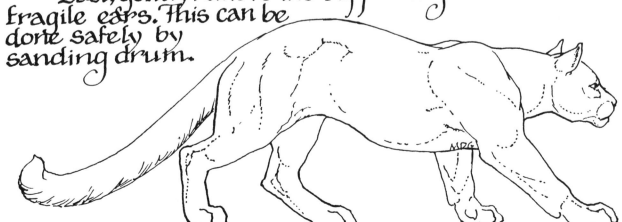

When a carving breaks...*Primal scream time*

Not to worry!

If there's an accident waiting to happen to your carving~ chances are, it will keep on waiting~ until the piece is just about completed!

When the damage is to a non load bearing extremity (ears, lips, noses...) carefully collect all fragments into a container with a lid (35mm film cans, yogurt cups and suchlike)~ don't lose a thing!

Wait until you've completed all the other areas, then glue the broken portions back in place with the same kind of glue used in making your blank. Any tiny chips missing? Pour out enough glue to fill the gap onto a piece of clear white paper or foil and mix in sawdust from this project. An artist's flexible palette knife handles both mixing and applying to the area of damage.

After the repair has dried completely, sand gently back into shape.

If you break a leg or neck, you'd better mend it now.

Trying to carve around the stump complicates getting a good fit when later replacing the broken bit. It's hard to carve four related legs when one of them is missing. Distortion will result.

This break must be 'pinned'.

PREPARE FOR SURGERY~

Use a dowel, whittle a peg, cut a piece of heavy gauge brass wire, which won't rust, rotting the wood.

Holding the break in place EXACTLY, pencil across both pieces an alignment key parallel to leg direction.

Take your smallest gouge, pivot it to make a 'pilot' depression in the very center of both stump and piece. If these are so small they'll be 'wire' pinned, your pilot should be a tiny 'X' made with the 'v' tool point.

With a drill bit the diameter of your intended 'pin'l and a very steady hand~ brace them on your bench) drill into stump, then piece less than ¼ inch, at the exact same angle as your alignment key.

Gently crimp the end of the dowel with the serrated jaws of a pair of pliers to increase glue surface and improve the fit.

Take a 'dry run' first, checking the fit of the dowel in the hole before loading it with glue and pegging it in, on the broken piece. Nip off the excess (with the wire-cutter part of the pliers if the dowel or peg is small.) Crimp the end of the dowel and try its fit into the stump. Be sure to check alignment, before glueing.

If the two edges aren't quite 'true', the remedy usually is to shorten the dowel or crimp it tighter. The dowel can be shaved to a point. In this case, mix a little sawdust with the glue to act as filler in the hole.

When fit and alignment are accurate, glue both peg and break. Hold the rascals in place with your fingers for a few minutes to set, then clamp with rubber bands or whatever will suit.

If you're pinning with metal, you may want to squirt a drop of a cyanoacrylate (instant setting types) glue down into the 'pin' holes, before inserting the pin. The break's surfaces should get carpenters glue. The cyanoacrylate instantly sinks into the wood pores, so by all means, be fast as well as accurate!

Broken toes or tail? Most toe tips don't need pinning; most tails, especially long ones need to be pinned.

This same pinning technique used to repair will fasten your carving to its base. Set the 'pins' in the carving first, so that they will be at right angles to the mount, crimping the ends and glueing ~ the way you did to mend the break! Mounting the completed carving is described in detail in its own chapter at the end of the book.

Let's fill any nail holes left from tacking your blank.

Split tiny pegs off of chips from the project. They should fit tightly, and be longer than the hole is deep. Try one for size, then cut others just like it.

Dip a peg into carpenters glue and wedge it into the hole as far as it will go. Needlenose pliers can exert considerable force.

When the glue is quite dry, snip off the protruding stub with your fishtail gouge. Your carving is now completed!

Congratulations!

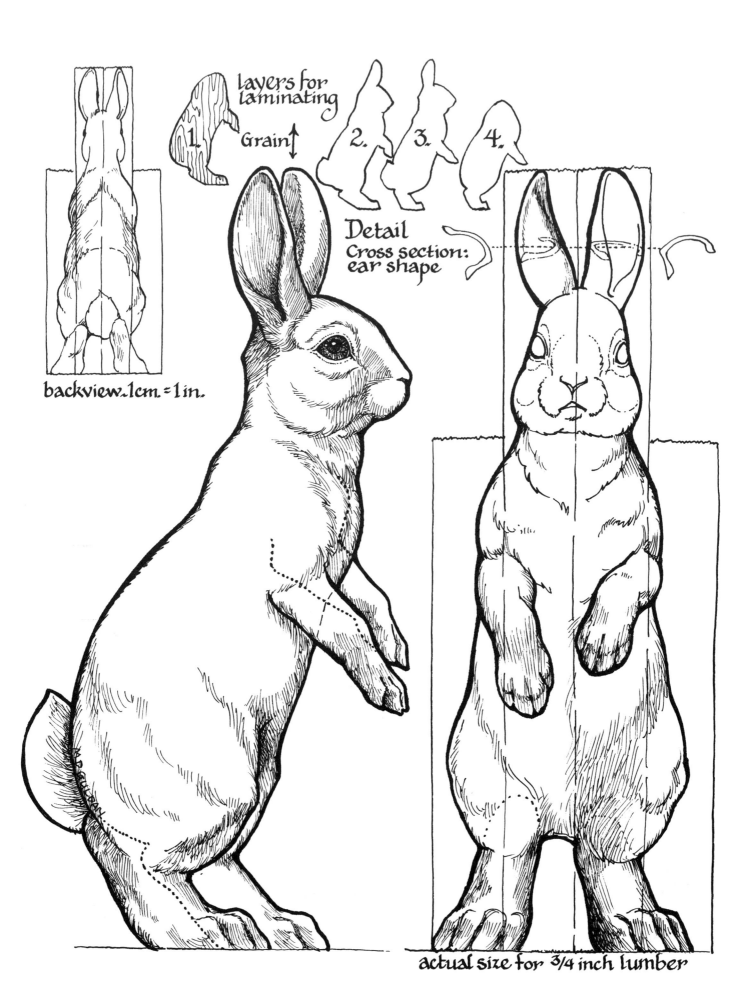

layers for laminating

1.

Grain↕

2. 3. 4.

Detail
Cross section:
ear shape

backview. 1cm = 1in.

actual size for 3/4 inch lumber

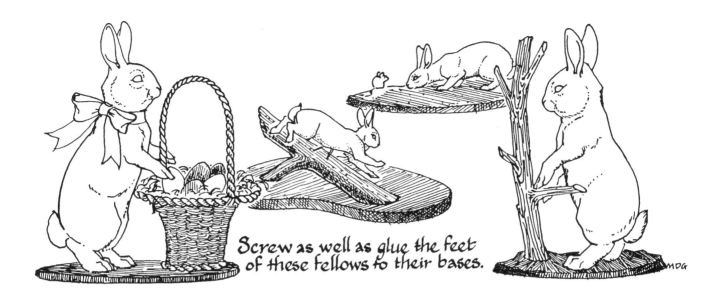

Screw as well as glue the feet of these fellows to their bases.

COTTONTAIL

THIS cottontail is having a look around, checking out the local scene for good-looking rabbits. If your choice of wood will allow, this rascal need not have its forepaws supported, though this aid can be authentically included.

We've always felt obliged to provide for baby rabbits left homeless when the hayfield is mowed and predators rejoicing, so have raised quite a few which have been successfully reintroduced to the wild. When the very young are staggering and blind, they're almost too tiny to hold for feeding, but they're a lot easier to keep up with. As soon as they open their eyes, they start leaping—straight up, like popcorn. The notion strikes at odd moments, and makes feeding as challenging as it is messy. They sleep in a tangled heap all day, amid the collected lining of their ruined nest, and gallop all night. To feel really inept, just try rounding up the bunch turned out in the bathroom for exercise!

Consequently, the farm seems a little over run.

In carving a rabbit, you will use the same procedure employed to do the cougar. The rabbit does afford the opportunity to give some special attention to ears; we'll develop techniques that can be used on the ears of other animals.

Live rabbits' ears are sufficiently translucent to glow when backlit by the sun. If you will be using basswood and planning a finish involving oil-resin or varnish, you can grind the ears thin enough in the back center portions to make then translucent without being prohibitively frail.

It is especially dramatic on a carving displayed with direct lighting and fascinates the viewers.

1. When your blank is prepared and you have penciled in front and back views where needed, you will want to begin roughing the bulkiest parts of the body. With your largest gouge or ballnosed carbide burr, start up the rump and back; remember that the backbone will form the highest ridge, with ribs and muscles sloping downward from it. The narrowest area is the hollow just behind the shoulderblades, which do not show the separation, left from right, that the cougar's did.

2. Once the topline has been established, turn your attention to the underside. Cottontails have longer fur underneath, obscuring sexual differences, but making a bit of a keel down the center, like a cat's. Be careful then, not to round off your rabbit's belly. The narrowest part of the ribcage is right behind the elbows; the widest, right above the "knees."

3. On to the legs and feet then. The most critical aspect of their shaping is to avoid making them chubby and round-toed like a cat's paws. Recall your own rabbit-handling experiences, perhaps limited to a macabre "lucky" charm on a key chain, but legitimate for observation nonetheless. The hair is short on the fronts of the legs, which are themselves angular and bony. The toes have high knuckles and very sharp claws, usually hidden by fur, making the toes look quite pointed.

You may find a taper burr more convenient for roughing here, before switching to gouges for the toe-shaping techniques illustrated for the cougar. Make the rabbit toes much narrower.

There is a dense, flaring cushion of crinkled hair padding the soles of rabbit feet, most noticeable on the raised hind heels, giving the feet a wedge shape.

The "knees" are rather pointed, the insides of the hind legs quite flattened, meeting in a "V" at the back of the hams. Shape up the tail while you're in the neighborhood. Don't be terribly concerned about a deep, sharp, definition between tail and body, a few "clean-up" strokes of your V-tool will take care of it, obscured as that line would be by hair and haunch muscles.

4. Let's go for the head next. In establishing its pear shape, it's best to cut the waste from the bases of the ears in order to get the convex curve of the forehead. There's a trefoil shape, like a rounded-off triangle, to the face when seen from the front. It's your goal in roughing.

Behind the puffy jowls, the back of a rabbit's head is narrow, the soft hair has been crushed into a mane-like ridge by the ears when they fold back.

You'll need a smaller tool, like a taper burr to shape the ruff of hair under the rabbit's chin caused by its neck compressing the skin.

5. Once the general planes of the face are shaped, pencil in the eye location, checking meticulously for symetry in size and shape as well as placement from all angles. Use the detailed eye instructions from the cougar pattern to help you carve them. As you adapt the forms to your rabbit's needs, be careful about the curve of the eyeball. Better too little curve than too much, or your carving will look pop-eyed, like a mouse.

6. Once the eyes have been carved, the other features can be done by adapting the cougar's nose and mouth techniques. Save the fragile ears for the last event of all.

7. Meanwhile, features done, go on to finish the body surface. Even if you plan to paint, there can hardly be a more attractive surface treatment for a carving than very shallow, descriptive cuts of your fishtail gouge. They should follow the shapes of muscle mass or hair direction, supplemented in thickly furred or folded areas with little strokes of your smallest gouge.

If you are experienced in "stoning," or using tiny abrasive wheels to carve the feathers of birds, you may want to use that skill to texture some of the furrier parts of your carving. Be scrupulously attentive so that none of those texturing lines are ever parallel to one another; it will destroy the illusion of fur. Instead cut the hair in little clusters of four or five strokes angling either slightly toward or away from each other.

8. As everything else should now be complete, let's get on with the ears. Be certain to pad your work surface carefully to avoid brushing any of your carving.

Illustrated instructions on carving ears follow the pattern. Good luck! By this time you are probably well warmed to this project. If you learn the techniques on these big ears, you'll be well equipped to handle the smaller ones in subsequent projects.

Some patterns for miniatures are included. Depending on the size of your burrs and abrasives, you may be able to do these with your grinder, doing just the detailing with a knife. If you prefer, you might just treat yourself to some whittling!

Either way, be careful of your fingers, but do have fun!

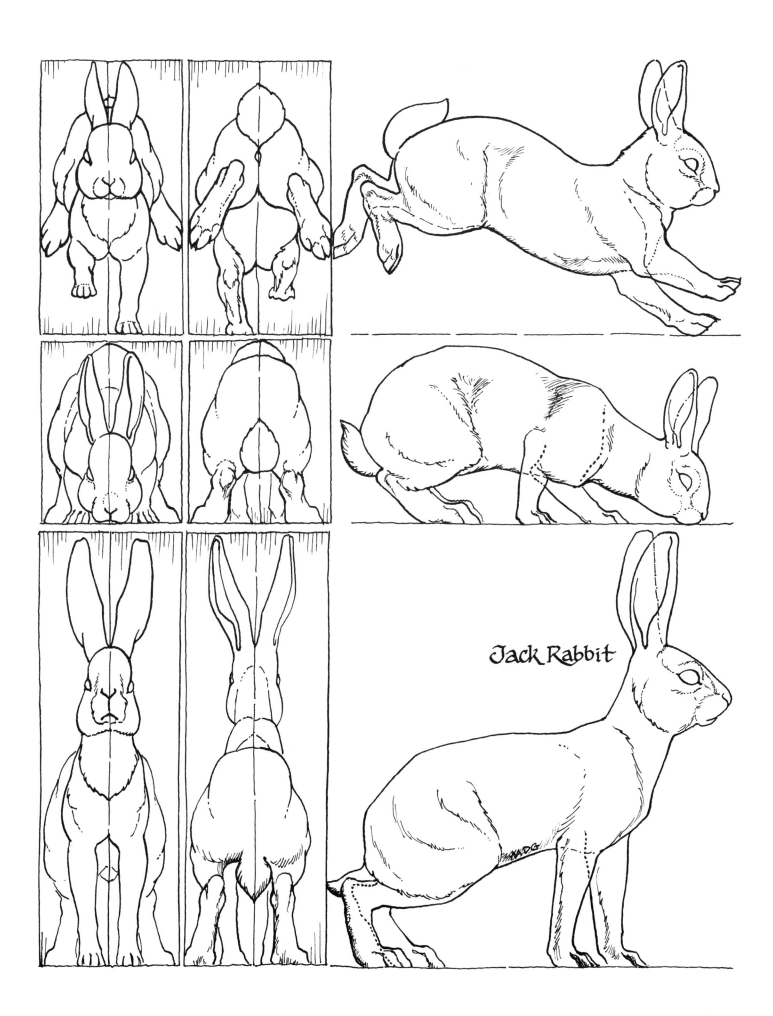

Jack Rabbit

Now, a lesson on ears~

The most successful ear is not a triangle whose acute angles were pulled around to the front, reminiscent of sprouting skunk cabbage.

Instead, ears have more character than that, as well as complex curves.

Usually they are better ground with burrs and abrasives, which stress the wood less than hewing away with a blade.

Let's not top critters off with a pair of skunk cabbages!

So what's the matter with that?

First, establish the 'focus' direction by grinding a plane between the front and back edges of the ear opening. A taper burr does this well.

Next, do a very general shaping of the outside of the ear, starting at the tip, working down.

Then clear the inside, tip toward base in front, first; back, after.

Check the pattern detail of ear cross-sections for the characteristic crease which allows a rabbit to fold its ears flat against its back.

The ears still should be thick and chunky at this point.

not to scale

Cut a little 'pilot' trench in the center of the ear opening with your smallest gouge or 'v' tool.

Using the taper burr, starting in the pilot trench, cut the ear opening from center toward the base behind the frontal folds. Guide the burr like you would handle a paring knife, trimming the 'eyes' out of potatoes.

From the 'median,' work your way backwards, up toward the tip.

With a very small sphere burr (an engraving cutter), ream out a narrowing hollow that extends into the 'skull,' if practical, or at least below the level of the slotted ear opening.

This next bit of shaping is best done with a fine abrasive, so that little wood is removed each time. Cartridge rolls, small, rolled strips of abrasive which expose fresh layers of grit with wear, will do this subtle modeling very well. Start inside the ear, cleaning up the grinder scuff-scars first, then develop the contours.

You want the base area nearest the actual oriface to be full and round. Don't worry about smoothing the bottom of the lowest portion; the cutter used to ream it left a passable surface.

The area nearest the front (or top edge in hoofed cud-chewers) has the deepest curve....see detailing cross section, noting that from the center, the curve opens more and more, until there is no cupping at the outside (or lower) edge.

Develop the inside modeling completely. As the inside of a rabbit's ear is relatively hairless to dissipate excess body heat, you will want this surface to be especially smooth. If the external shaping which follows retains a slight texture from the abrasives, this should be in the same direction as the hair grows; base to tip in back, diagonally from base to edge in front.

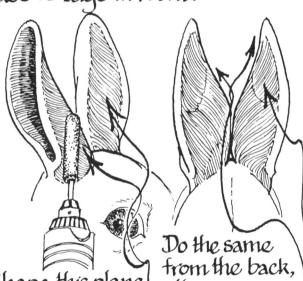

Shape this plane, leaving a slightly raised edge, but with no obvious demarcation. this strengthens the ear.

Do the same from the back, allowing a vague ridge to remain at the 'crease'. Pay close attention to the dished aspect to give the ears a livelier attitude.

Make sharp-edged planes intersect all around the opening.

Don't 'box' edges; that's not realistic.

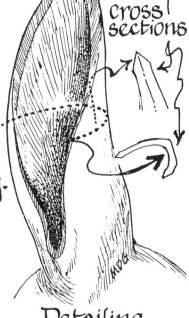

cross sections

Detailing
Now you've got a good grasp of ears!

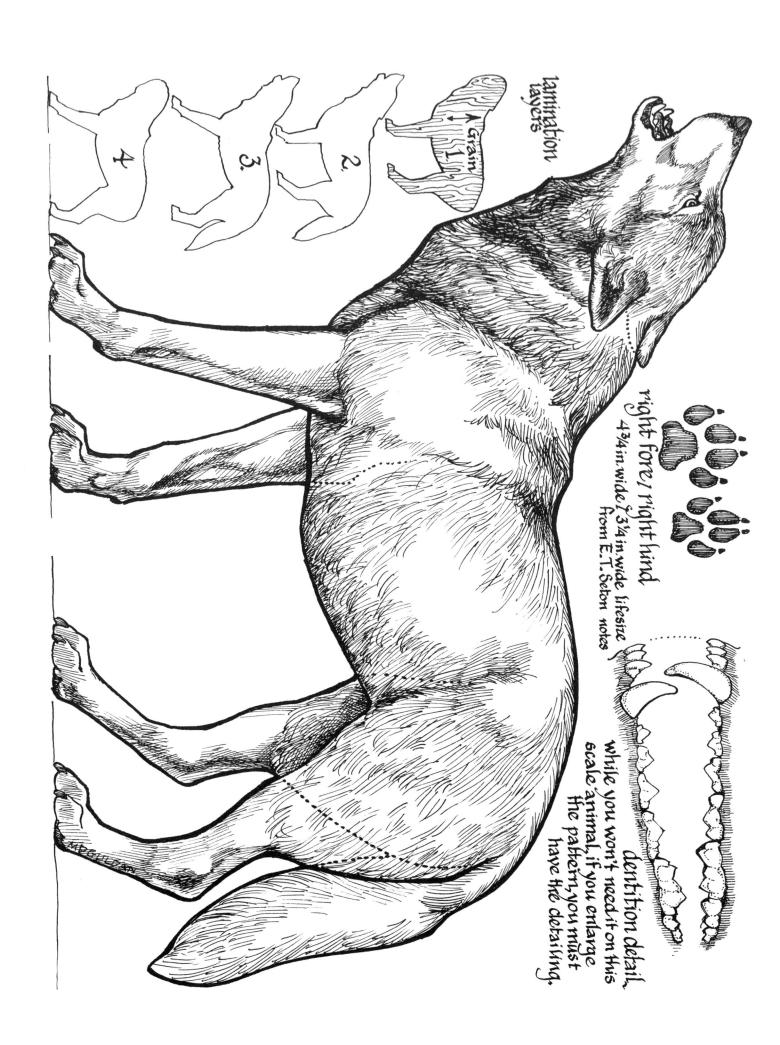

lamination
layers

4.

3.

2.

1.

Grain

right fore, right hind
4¾ in.wide ₹3¼ in.wide lifesize
from E.T. Seton notes

dentition detail,
while you won't need it on this
scale animal, if you enlarge
the pattern, you must
have the detailing.

MCGILLEAN

WOLF

THE howling wolf has totally concentrated on his vocalizations, his body is quite relaxed in order to divert all his energy into his voice. It is winter, and he is blanketed in a dense, luxuriant coat of weather proof fur. In his "summer suit," he would be a spare, leggy caricature inadequate of his reputation. On this account, you will notice when viewing live specimens, wolves actually do not resemble any modern dog breed. They are too rangy and long-legged to be currently dog-like. Their faces are very long and narrow, the heavy hair makes their eyes, with that very long lachrymal gland slot, appear small, and close and speculative.

These wolves are the "alpha" members of the pack, the confident, secure monarchs. Though their heavy fur obscures their gender, the howling wolf and the snarling miniature are both males. Females, such as the stalking miniature, are smaller and rangier. Live, they would seldom stand and never walk with their feet so widely splayed, but this adjustment was necessary for the stability and durability of your carving. The miniatures lend themselves well to habitat groupings with other wolves, or possible prey species, duplicating chance encounters that might occur in nature.

Now, let's carve!

1. The scheme will be the same as you followed on your cougar; after you have constructed your blank and penciled in front, back and dorsal views, begin your roughing out on the rump and trunk with your large ballnose burr or fishtail gouge. Cut the hips relatively narrow across the top, as in the rear view, while flaring the thick pelt on the hindquarters, especially toward the back.

Once you note the "lay" of the especially heavy fur forming a layered ruff on the wolf's jaws, neck and shoulders, shape these areas in a general way. Since the ears project so little, go ahead and remove the waste from their outsides, then work your way up the muzzle.

2. When your topline has the bulk of its waste removed, work next on the ribs and belly. The fur is so dense that it compresses into a bit of a peak the length of the stomach, front to back.

Check to see that you have reduced the sides of the ribcage sufficiently; there is quite a lot of waste there. The barrel should not stick out beyond the shoulder cape or hindquarters when viewed head-on.

3. As you clear the lower part of the head and neck; next, allow each of the layers of the ruff to come down to a necklace point at the bottom. Be sure to maintain the very triangular character of the fur padding the jowls, most noticeable when viewed from the front.

During meal times, some very toothy bickering erupts as the offended parties curl back their lips to expose fang and gum, snarling and glaring straight ahead. Slashing bites to re-establish superiority often ensue. The protection afforded by the dense fur of cheeks and neck reduce the incidence of actual bloodletting to potent gestures.

4. Because this relaxed tail is not a fragile pose, cut away most of its waste to give

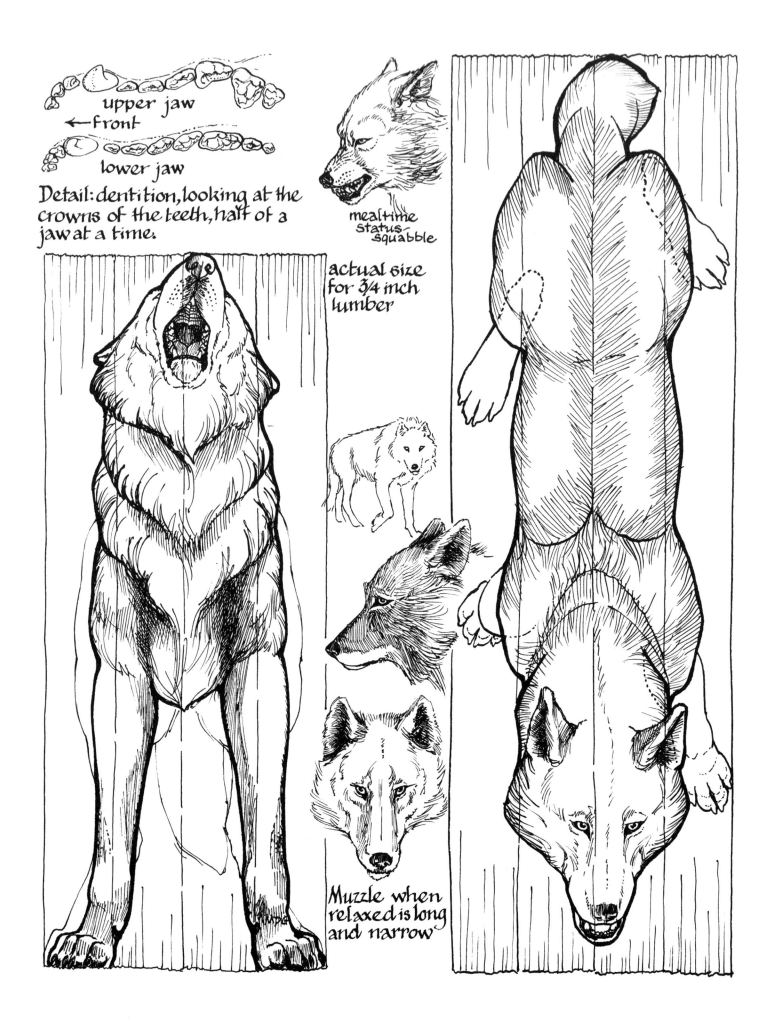

upper jaw

←—front

lower jaw

Detail: dentition, looking at the crowns of the teeth, half of a jaw at a time.

mealtime status squabble

actual size for 3/4 inch lumber

Muzzle when relaxed is long and narrow

yourself access to the legs. Let's have a go at those legs now, starting on the feet, first roughing out the form, then returning to do the details with smaller tools.

As with the rabbit's feet, beware of making the wolf's toes chubby and rounded like a cat's. The steps followed in doing the cougar's paws, however, do adapt to the wolf's longer, bony toes. There should be an obvious angle to define the knuckles. The toes should taper to a point at the nail in front.

Those nails need not be completely undercut; they will be less likely to break if they are shaped by a slot cut with the V-tool which only slightly angles under the toe.

Don't omit the dewclaws on the insides of the forelegs only, just below the "wrist." These are most easily shaped with the corner of a small gouge.

The legs are very long and slender, covered with dense, short fur which looks a little incongruous emerging from the long, shaggy body coat. To do the softened modeling, abrasives mounted on your grinder are very effective.

The upper parts of both fore and hind legs are rather flattened on the insides, more rounded on the outside. A leggy domestic dog can be a helpful model for the musculature. A turn-of-the-century hunter turned naturalist, Ernest Thompson Seton, noted in his detailed studies that the tracks of wolves were indistinguishable from those of large dogs. There's a pretty large dog snoozing out in our kitchen right now; he's an Airedale, 27 inches at the shoulder, 100 pounds, with big fuzzy feet—still an inch smaller than Seton's wolf measurements. One is inclined to wonder what was running loose in those "good old days."

5. Now that you've finished the legs, let's do the head, next. Again, if you modeled the legs with abrasives, you can do the same with the face to attain that softened contours.

In order to carve the interior of the mouth, use a very small sphere "engraving cutter." Yes, it's slower than clearing the area with a small taper burr first, but the control is tighter, and the surfaces mostly finished on completion of the modeling.

While in the lower jaw, the teeth and tongue will need to be indicated in some detail, the same attention is not needed on the upper front teeth, hidden as they are by the lips. The molars, though, are a good inclusion, along with the ridges in the roof of the mouth. Hollow a bit of the back of the mouth if possible, to hint at the throat and sound it is making.

Use the cougar facial detailing to give some specific approaches to doing the wolf's eyes, nostrils and ears.

6. Be sure your work surface is amply padded when you begin to texture the body coat, to avoid bruising the crisp edges of your cuts.

All over "stoning" or "burning" fur texture is a bit too overpowering on this scale, making the fur the most important feature, when the howl should be.

Instead, texture with small, short gouge cuts, following hair direction, though no strokes are exactly parallel to one another.

Begin with your small gouge; enhance shadowed areas with additional cuts of your smallest gouge, as in the illustrated detail. Further imply clumped, shaggy fur with small V-tool cuts.

Get the feel of the technique on the barrel first, then work from head to tail.

Test the impact of your cuts by checking their shadows from time to time. Stand your wolf under direct overhead incandescent lighting.

Distractingly dark lines can be lightened by shaving down their sides slightly, opening them up. Areas lacking contrast need to have their smallest gouge cuts deepened.

This approach can be applied to thick fur on all kinds of animals, now that you have a feel for it.

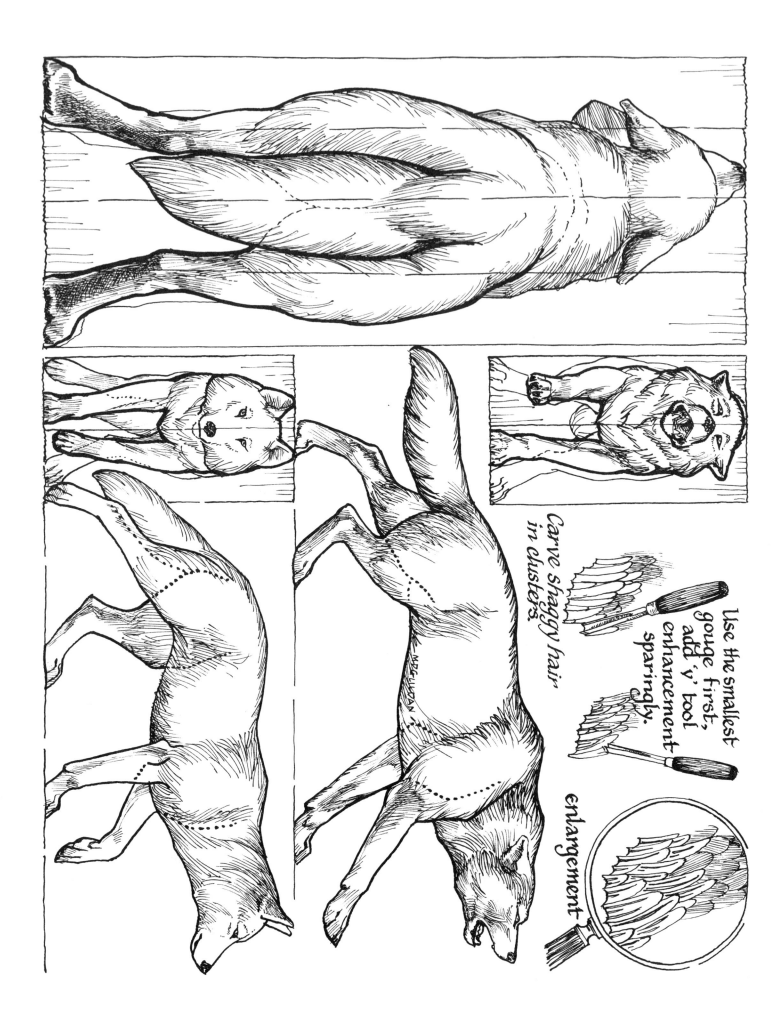

Carve shaggy hair in clusters.

Use the smallest gouge first, add 'v' tool enhancement sparingly.

enlargement

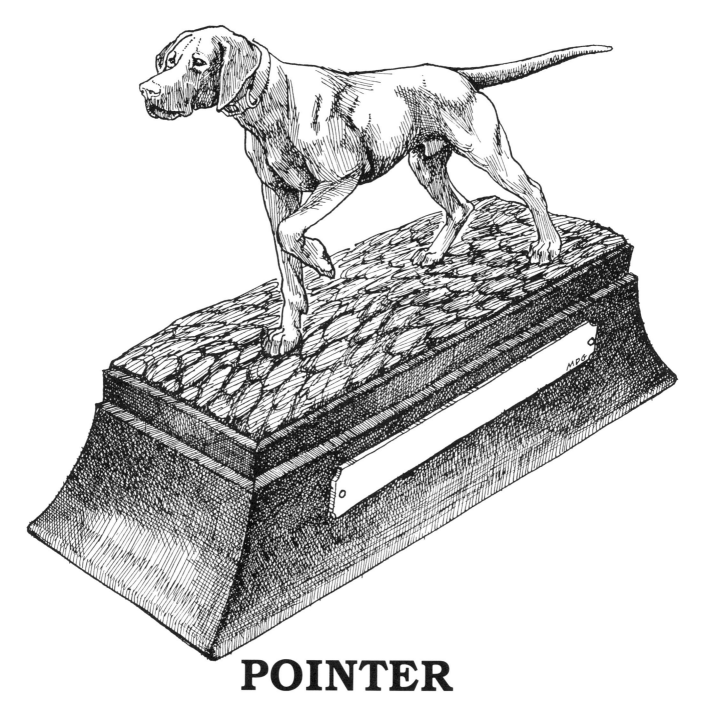

POINTER

WITH the addition of the appropriate background, the carver of a relief can turn a bird dog into a new national champion a lot faster than any handler ever did.

Picture yourself at The National Field Trial held at Ames Plantation, in Grand Junction, Tennessee, on properties specifically preserved and prepared for this annual event.

The winning dog and his handler meet the press from the front steps of the "big house" at Ames Plantation, with one of the three massive silver trophies comprising part of their winnings in the foreground. Most of the recent winners have been pointers, whose long legs and close, hard coats suits them especially for the grueling three-hour, 15-mile long braces.

If you prefer setters, since this is your fantasy as well as your scene, make your winner a setter, if you like.

In order to focus on the dog, handler and trophy, the architectural detailing has been minimized. It should be carved in very shallow relief to avoid strong shadows and provide

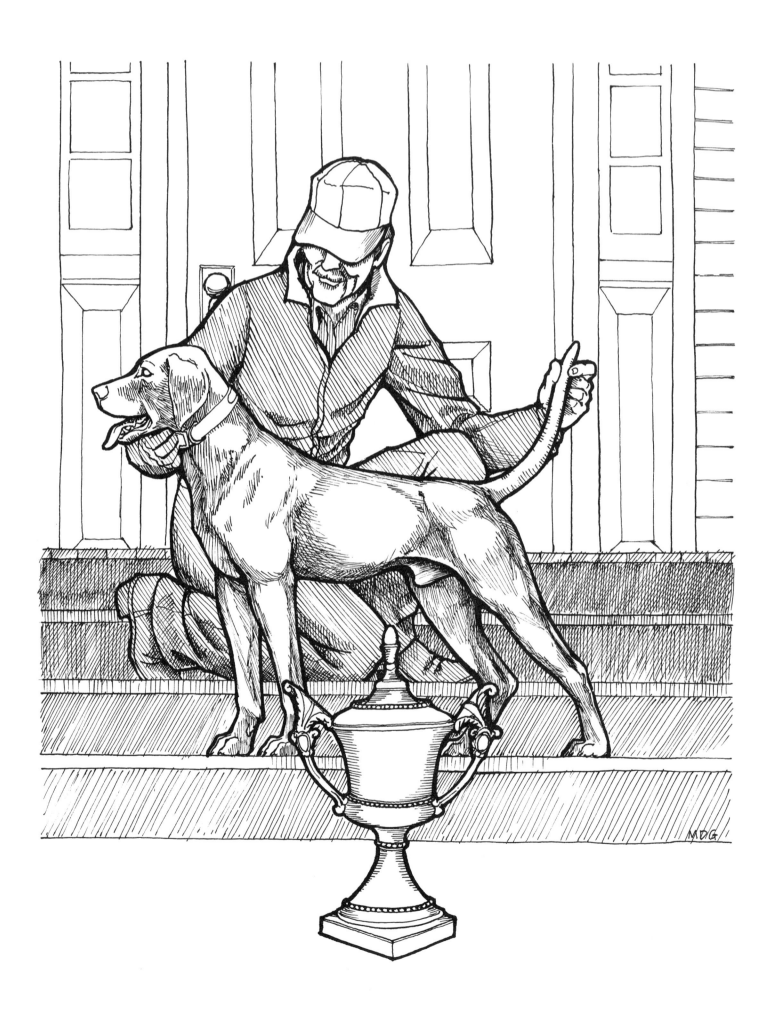

contrast with the sharply detailed, more raised center of attraction.

While one usually begins a relief with a series of "stop cuts" done by mallet and chisel, outlining the highest features, the relative frailty of the dog's legs and the trophy handles suggest instead a whittler's stratagem. The "stop-cut" can be made with the point of the far more agile bench knife, held two-handled for increased pressure and control.

Secure the workpiece, then make your first knife trip to establish the outline, followed by a second pass with increased pressure. As a safety precaution, slightly angle this cut outward at the bottom, away from the focal point objects. Those can then be undercut after the background is cleared and danger of a stray chisel slip is past.

The stop cut can be reinstated as often as necessary.

In fact, once the modeling of both foreground and background have been completed, rather than cleaning up around the edges of the "centerpiece" with a V-tool, incise one more good stop cut with the bench knife. The V-tool does not cause a strong enough, precise shadow; the imitation of its groove made with a second outlining cut of the bench knife remedies this with a valuable variety of shadow-making angles and depths.

As if chip carving, cut the running "V" outline, raising the knife handle away from the work surface to make a deeper, more acute angled trench, resulting in a darker outline shadow around the dog. Lower the handle nearer the workpiece to broaden the angle of the outline cut, reducing the crispness of the shadows around the trophy and handler.

To carve the pointer as a three-dimensional figure, procede as with the cougar, plug-in tail included.

Follow the same order in carving, working from the least fragile trunk and neck, to most delicate feet, legs and head. The tail will again be last.

For legs and a tail as frail as these, depending on your wood, you will probably find that very little shaping can be safely done with your coarse burrs. Even when run at very slow speeds they are still a little too likely to shatter the wood. While it will take a little longer, some very successful modeling can be done with abrasive drums, starting with the largest grit, changing to successively finer.

Since you will be depicting a superbly conditioned animal, this is the perfect opportunity to hone your muscle modeling skills. Arm yourself with a good anatomy manual diagraming the dog's subcutaneous musculature so that you can lightly pencil it on your carving. Be cautious about indicating edges of the muscle masses with a V-tool, which makes too sharp a "valley." Instead, model the depression with a skew or straight chisel, shaping from the mound over into the crease to form a broad angled "cut."

Remember that this is a long-distance runner, so is necessarily much leaner than a weight lifter. Keep your modeling subtle; in your enthusiasm, don't let your dog get all "pumped up" and lumpy with overdone muscle bulges.

Because pointers have such close, hard coats, no hair detailing will be needed.

If you chose to turn the dog into a setter instead, you will not need to be as concerned with musculature as you will be with hair texturing. Substitute the gouge work described in the wolf detailing, it will be very effective. The top surfaces on a long-haired animal are somewhat smooth, needing just shallow cuts of the medium gouge. The hair hangs to a bit of a point underneath the body and tail, also on the backs of the legs, where the smallest gouge makes the staggered clumps of cuts best.

Be very sparing in your use of the V-tool cuts; should you use the tool to texture the animal all over, the resulting corduroy surface will become the dominating factor. Your viewers will see the hair before they see the dog in that case.

Enjoy what you are doing in any event, because your pleasure will show in your carving.

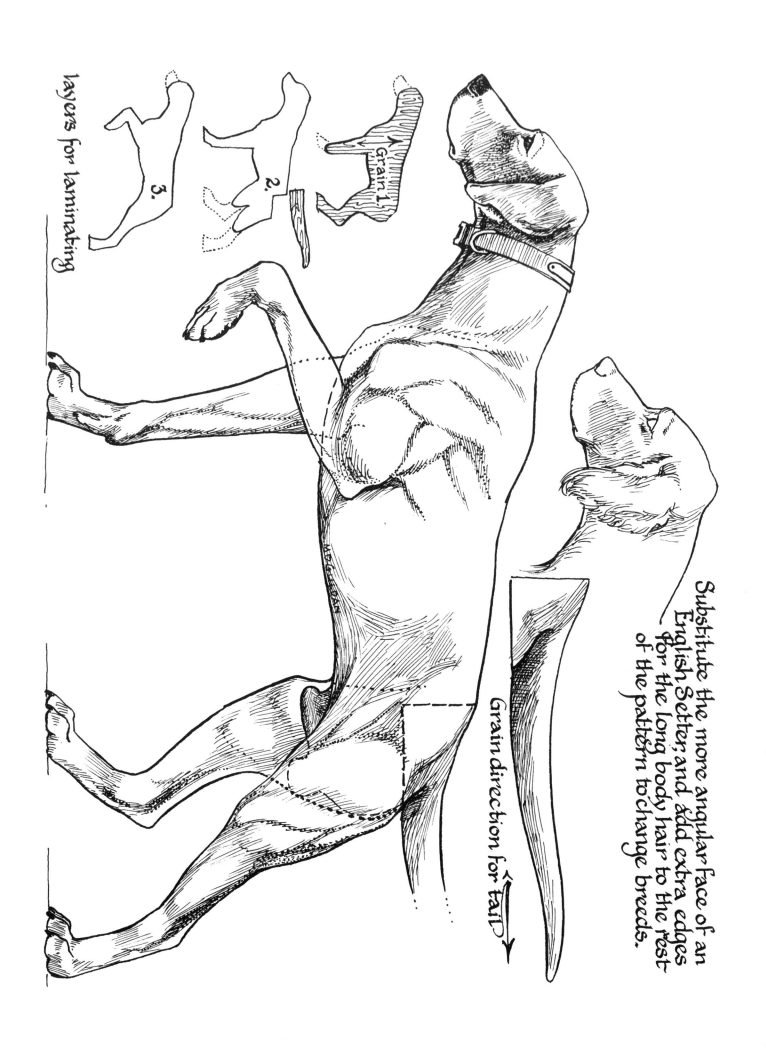

layers for laminating

3.

2.

Grain 1

M.R.GILLMAN

Grain direction for tail

Substitute the more angular face of an
English Setter, and add extra edges
for the long body hair to the rest
of the pattern to change breeds.

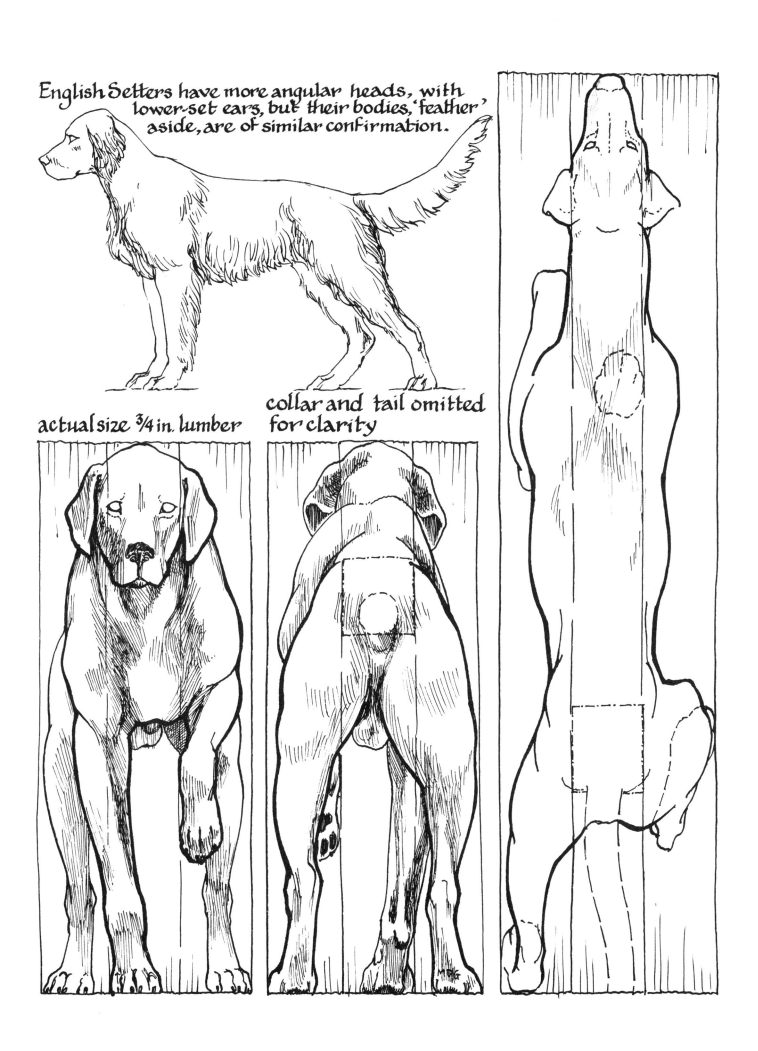

English Setters have more angular heads, with lower-set ears, but their bodies, 'feather' aside, are of similar confirmation.

actual size ¾ in. lumber

collar and tail omitted for clarity

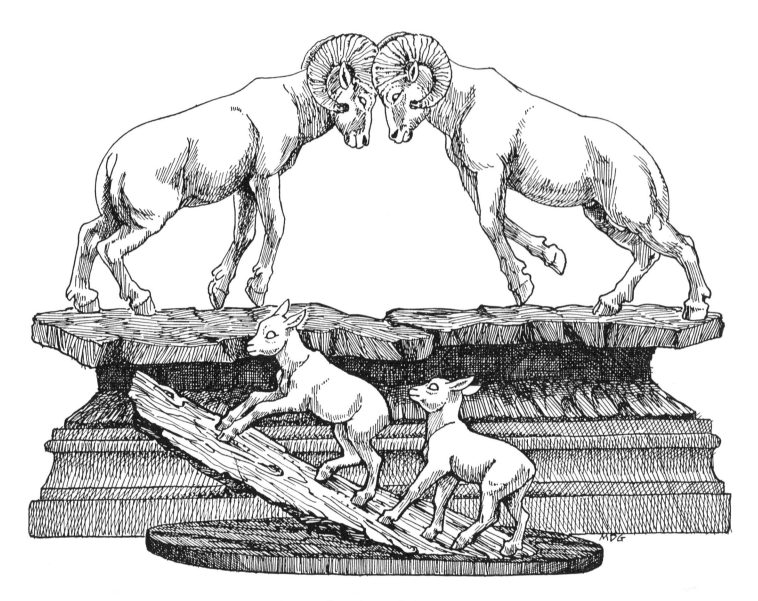

BIGHORN

THE dramatic headgear of the Bighorn Ram is a perennial crowd-pleaser; just note the frequency with which he's featured in starring roles in nature magazines! Those horns look a lot more complex than they actually are to carve; they will be a challenge only as long as it takes you to figure out their combination of spirals and flattened sides.

Notice that the numbered layers of the blanks encourage you to omit unnecessary face and leg portions (enclosed in broken lines) for greater economy of material.

A single combative ram would probably need to be positioned with a marauding wolf to give purpose to his pose. The snarling wolf pattern enlarged to four inches tall at the shoulder would suit this purpose, especially if his head was turned at a right angle to his body, facing the attacking ram.

By substituting the "B" legs for two outlined legs, the pattern can provide two slightly different rams embattled over control of the "harem."

Once you've constructed your blank, be meticulously accurate in penciling in the dorsal view, especially in outlining the width of the neck in relation to the curl of the horns. Also watch the angles of those driving hind legs. Because quadrupeds propel themselves with their powerful hind legs, the crouching thrust there is vital to the dynamism of your piece.

A WOODCARVER'S WORKBOOK

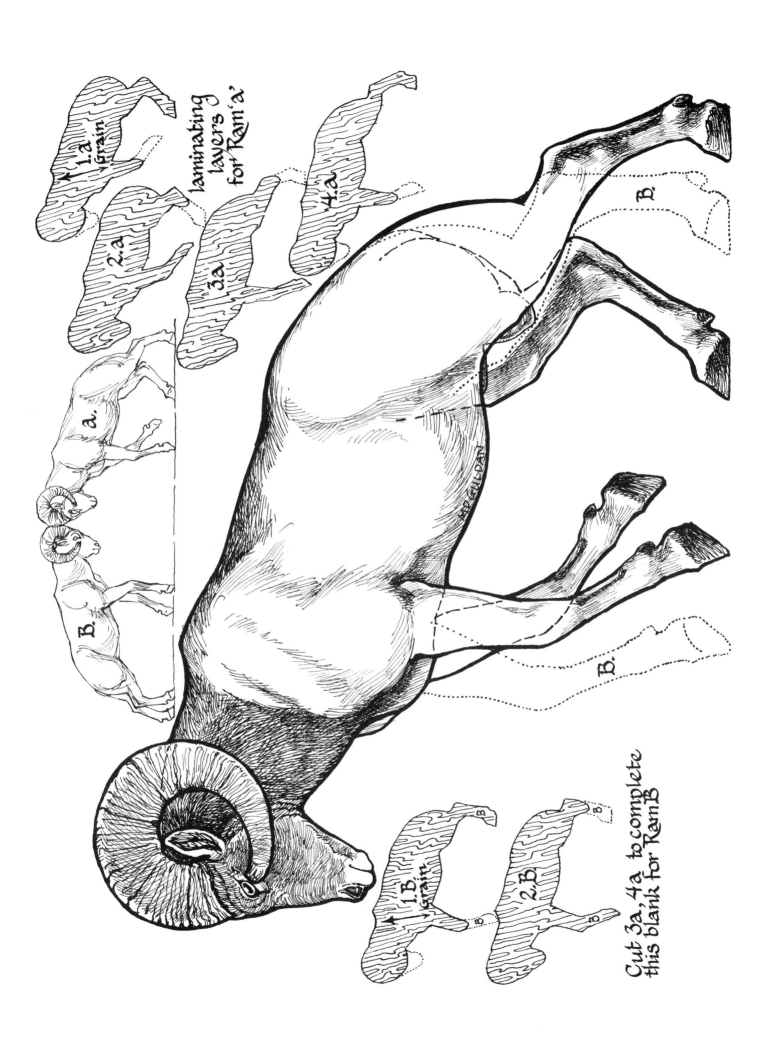

laminating layers of
for Ram 'a'

1.a grain

2.a

3.a

4.a

a.

B.

Cut 3a, 4a to complete
this blank for Ram B

1.B grain

2.B

B

B

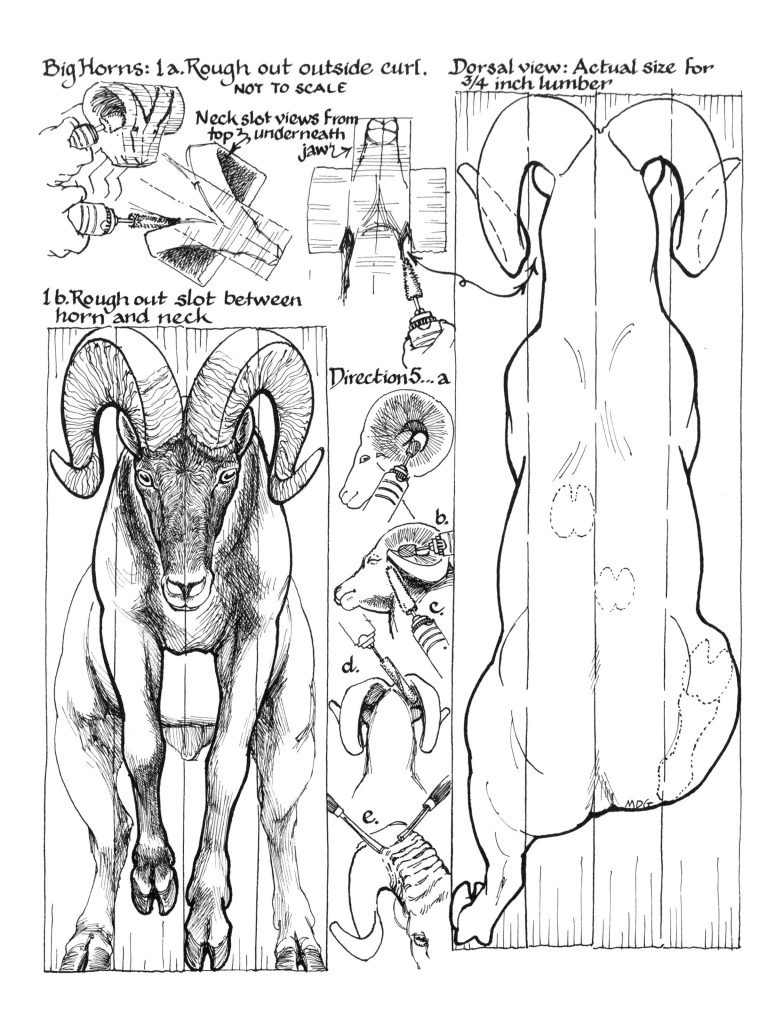

Big Horns: 1a. Rough out outside curl.
NOT TO SCALE

Neck slot views from
top & underneath
jaw

1b. Rough out slot between
horn and neck

Direction 5...a

b.

c.

d.

e.

Dorsal view: Actual size for
3/4 inch lumber

MDG

1. As usual, begin your roughing out up the rump, 'round the trunk and over the shoulders. When that is done, reduce some of the excess weight of waste around the horns. A sphere burr is easiest manipulated here.

First, clip off the square front corners of the blank, ahead of the horn tip to the top of the brow spiral. Gently hollow the inside of the spiral, stopping at the glue seam between the outside and middle blank layers so that you'll be sure to leave enough wood for the ears.

Next, cut a small slot between the neck and horns to prevent grinding into the neck inadvertently when cutting the horns. It will also enable you to complete your shaping of the neck and shoulders. The small taper burr which is best suited for these confines will not reach to the bottom of the neck, so will need to be applied to the back and bottom of the intended gap. A jeweler's saw can be used here instead.

No matter the equipment, be sure to have wood for the ears.

Taper the sides of the face toward the muzzle a little, for convenience.

2. Let's turn to the legs before we make the horns any more fragile. Be sure the edge of your workbench is padded to protect your piece. A discarded bathtowel folded under a leather scrap works well.

Now, some concessions to the medium had to be made in designing these legs. Once aware, you'll understand and can duplicate the illusion used to disguise this.

In life, the ram's legs are quite slender in proportion to his rather bulky body. They are also flattened laterally, especially on the insides. For the durability of the carving, the legs must be more robust than normal; most of the additional bulk will be on their sides. The live animal's hooves are more widely cleft than we'd better carve, or we'll have nothing left to peg the base onto, when mounting the finished carving.

As you may have found with the dog's slight legs, burrs can safely do only a very rudimentary roughing. Cut from the hooves toward the body just to get the bulk of the waste off the sides, leaving the legs rather square. Switch to abrasive drums to deal with the rest of the waste.

Depending on your stock of abrasives, you may be able to do your actual modeling with them.

Let no part of those legs get too round; even the backs of the knees come to a softened point. Do a little visual trickery here, above and below both knee and hock. To disguise their sturdiness, make their front and back edges a bit narrow. Imagine a cross-section through the legs as a gentle diamond shape.

As you fit the legs into the body, observe that the forequarters, particularly around the fronts of the shoulders, are square and angular, where quite the opposite is true of the hindquarters. His rump is very rounded, with only a tight, narrow crease between his hams. His tiny tail clamps into the upper part of that groove so tightly that it is visible only from behind. In the excitement of combat, the ram's genitals contract for protection.

3. While in the locale, let's finish up the hooves properly. The nail portion is stumpy and upright, with a previously mentioned deep cleft between the hooves. Don't divide the hoof cleats clear through, from front to back; instead, use the V-tool to establish the path, because it's more easily controlled. Then, return with the bench knife to whittle the cleft as a broad angled, yet relatively shallow valley.

For the heel bulbs, use the curve of your medium gouge, inverted, pushed up and over into the cleft from one side, then the other. The tip of your bench knife, or tiny ball-shaped engraving cutter to clean the small hollow from below the dewclaws to the heel bulbs.

The soles of the forefeet are visible from behind; while it may seem a trifling point, they should not be left flat. The hard nail forms a sharp outside edge, hollowed slightly at the toe.

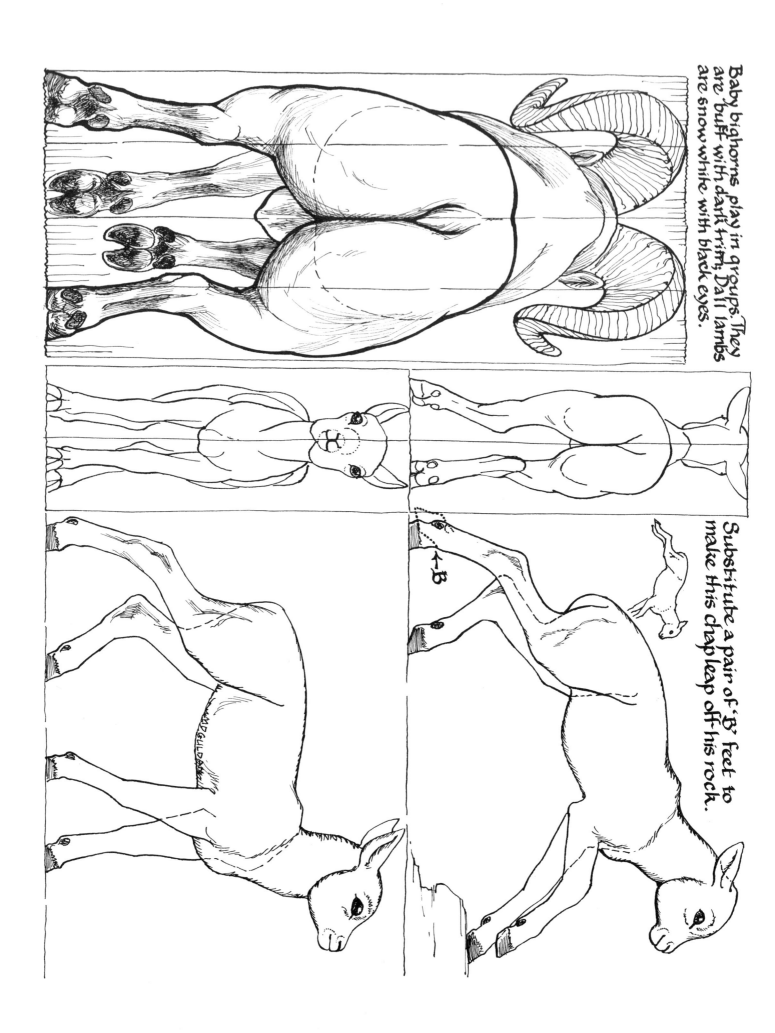

Baby bighorns play in groups. They are buff with dark trim; Dall lambs are snow white with black eyes.

Substitute a pair of "B" feet to make this chap leap off his rock.

←B

The "tee" engraving cutter handles this well. Terrific traction is provided by the rubbery sole, quite rounded at the heel. The dewclaws are characteristic projections, like little spurs, shaped handily with the smallest gouge.

4. Turn next to the ram's plain, roman-nosed face. Use your fishtail gouge to trim his face down to size, being especially attentive to the projection of eyes and brow ridges at the base of the horns. The gouge cuts should accent the lean angularity.

Pencil in his features, checking size and symmetry from every angle, then, employing the same techniques illustrated for the cougar, carve his features.

To keep the small ball-shaped engraving cutter from wandering, cut a tiny pilot chip in the center of each nostril with the V-tool. It will make the nose reaming a lot less hazardous.

5. Save the ears for last; let's tackle these horns! Their basic shape is triangular in cross section, as they emerge from the skull. The top of the horn is narrower than the sides, and a bit convex, where the sides are slightly concave, especially on their upper edges. By the bottom of the first curl, the triangle has decreased to nearly oval.

With that in mind, pencil plan the size of the opening inside the curl of each horn, and the ear location.

This opening can probably be ground with less stress to the wood (and your nerves) using a little vanadium cutter burr with a rounded tip, or the point of your carbide taper burr, run at rather low speed.

Well behind the proposed ear, grind clear through the waste inside the horn curl, being cautious not to punch into the neck in your enthusiasm to start the opening. Unless you've had previous experience with horns like these, and have already worked out a strategy for carving them, you will next want to clear the whole opening inside the horn curl, like some outlandish donut.

When the opening is complete, start shaping the tip of the horn, cutting your way back up the curl, forming the horns' flattened outside.

When you turn your attention to the facing sides of the horns at the back of the head, be careful, as you hollow, not to remove what should remain as skull and hefty neck. Beyond this point, the horn shaping from the back is best done with abrasives, if yours are small enough to fit without scarring the neck.

Each year's growth is marked by a series of ridges on the horns of the live animals. The most pronounced ridge in each series is an age indication like the annual rings of a tree. Battered by combat, the rams' horns are splintered on their tips, worn and chipped on the contact surfaces elsewhere. Give the horns a rugged texture with your V-tool and small gouge, inverted to nick the horn edges for growth rings and chips.

Don't make any of your growth rings too even or equidistant, or they will look like corduroy, not a proper set of equipment for this robust beast.

6. Only after the horns are complete, finish this fellow off by carving his little pointed ears. You may actually find that because of its long shank, your fishtail gouge can reach this area most easily. Don't hollow these ears much, and at that, the "inside job" can be done with the tiny round engraving cutter.

For a whimsical change of pace, carve some baby "bighorns." By changing the hind feet of the climbing lamb, using the dotted pattern twice instead, he can be turned into a little chap bounding among his buddies, for variety.

Properly, one should not mount a batch of babies on a base with a ram, who would have left the childrearing to the ewes. Since the lambs play together so actively, group these rascals in a lively game of chase on a craggy hillside for the greatest authenticity.

WHITETAIL BUCK

IN this project let's try to capture the elusive impression of now-you-see-it, now-you-don't that is the essence of the whitetail deer. Stop and think of your own encounters with these evasive animals; what did you actually see?

Probably it was no more than a split-second glance at his startled face, flaring ears and crown of antlers, then his rapidly receding flag as he bounded away.

In drawing and painting, the more tightly detailed the rendering, the more static, or

stationary the object becomes. Conversely, the more loosely impressionistic the treatment of descriptive detailing, the more activity is implied about the subject. Since deer look fast even when standing still, let's make this premise work sculpturally.

Pick a colorful wood, or plan on a dark, substantial stain to concentrate attention on the form. Firmly intend to keep detailing at an absolute minimum. The patterns have been drawn nearly devoid of detailing below the buck's chin to help you edit non-essentials.

Before you begin the leaping buck, it would be wise to have on hand the object of his jumping, the limb or driftwood simulating a fallen tree, for example. It need not be premounted on the permanent base, but as well as checking for soundness, you will want to see about positioning. The pattern may need adjusting, stretching the leap or tucking the forelegs to better suit the buck to the mount.

To give the standing buck a more animated pose, turn his head. This will be especially helpful if the finished carving is to stand on a mantel or shelf with his back to the wall. For a slight turn, use the "B" option, laminating a second head layer in your blank. Further "B" views are included in the front and dorsal plans.

To turn the buck's head at a right angle to his body, carefully saw off the head at the dotted line indicated on the blank, and reattach it facing the preferred direction.

It is essential that this cut be as smooth and straight as possible to keep the surfaces matting; this can be reliably done with a small back-saw, used for dovetailing and model building. It's a good idea to pin this joint with a small dowel for stability.

While it is certainly possible to make up a blank including antlers and ears already in place, they will be so fragile and cumbersome that they'll be frustrating to protect and work around. Plugging in these parts made separately allows greater adjustability in positioning, as well as the freedom to make as many attempts as you want or need.

Now, let's get the business of carving underway!

1. When you've penciled front, back and dorsal views onto your prepared blank, start roughing out with your largest gouge or ball-nosed burr. Work, as before, from rump toward shoulder, noting the spare angularity of your subject.

The hips are rather narrow, peaked on top, the haunches are slightly flattened on the sides. The ribcage is a long oval, especially behind the shoulders and forearms. The shoulder blades and underlying spurs of the thoracic vertebrae make the shoulders quite prominent and peaked, in contrast to the fullness of the neck.

Once up behind the ears; stop, because there's little waste on the front-facing heads. Turn your attention to the bottom of the ribcage. Don't let this rascal stay too rounded! On the leaping buck in particular, the back of the ribs should taper into the taut abdominal walls, stretched by the flexed haunches.

Deer are capable of some fabulous leaps because, unlike most quadrupeds, the bones of their shoulder and forearm, above the elbow, are not strapped tightly to the ribcage by muscles. This extreme flexion is most noticeable in the leaping buck, so suggest this by your modeling of the hollow below the shoulder blade and around the elbow. It need not be dramatically undercut, especially not so soon, but don't mash the elbows into the barrel as you rough out.

2. Once the body is under control, shape the lean, angular head. From the side or head-on, it's wedge shaped character is obvious. As a general rule, in long-faced animals, the bridge of the nose, from below the eyes to the back of the nostrils, is the narrowest feature of facial anatomy, because it involves so few facial muscles. The squadron of muscles controling lips, nostrils and jaws, originating in the muzzle area, account for the little fullness in the cheeks.

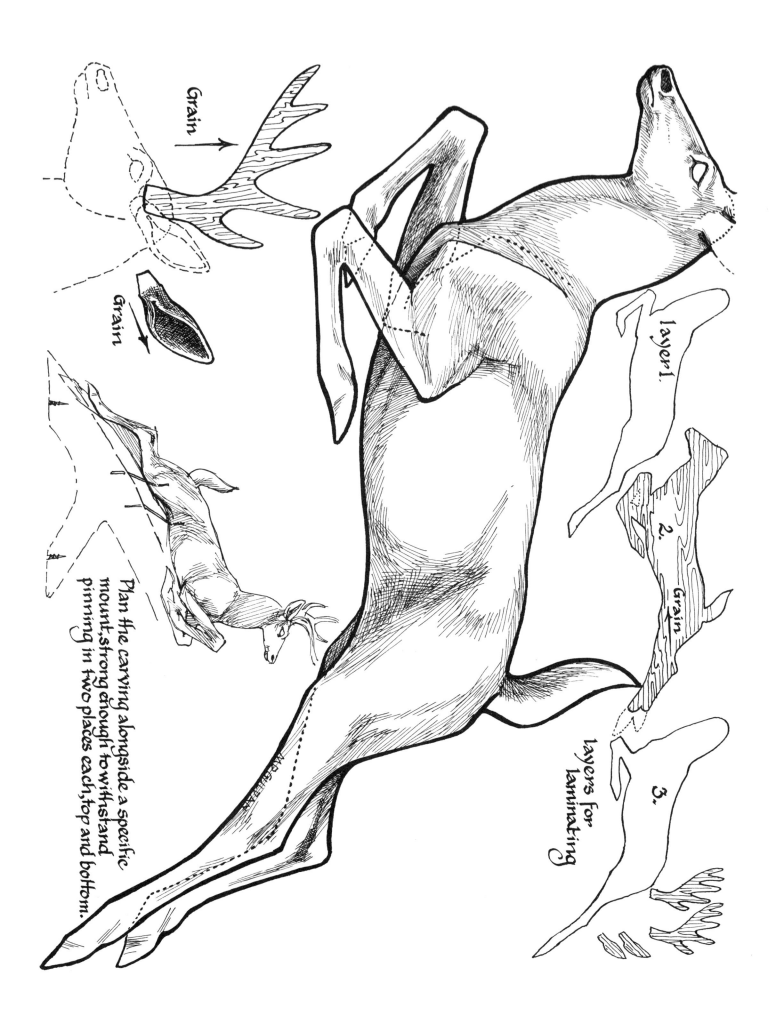

Grain

Grain

Plan the carving alongside a specific mount, strong enough to withstand pinning in two places each, top and bottom.

layer 1

2.

Grain

layers for laminating

3.

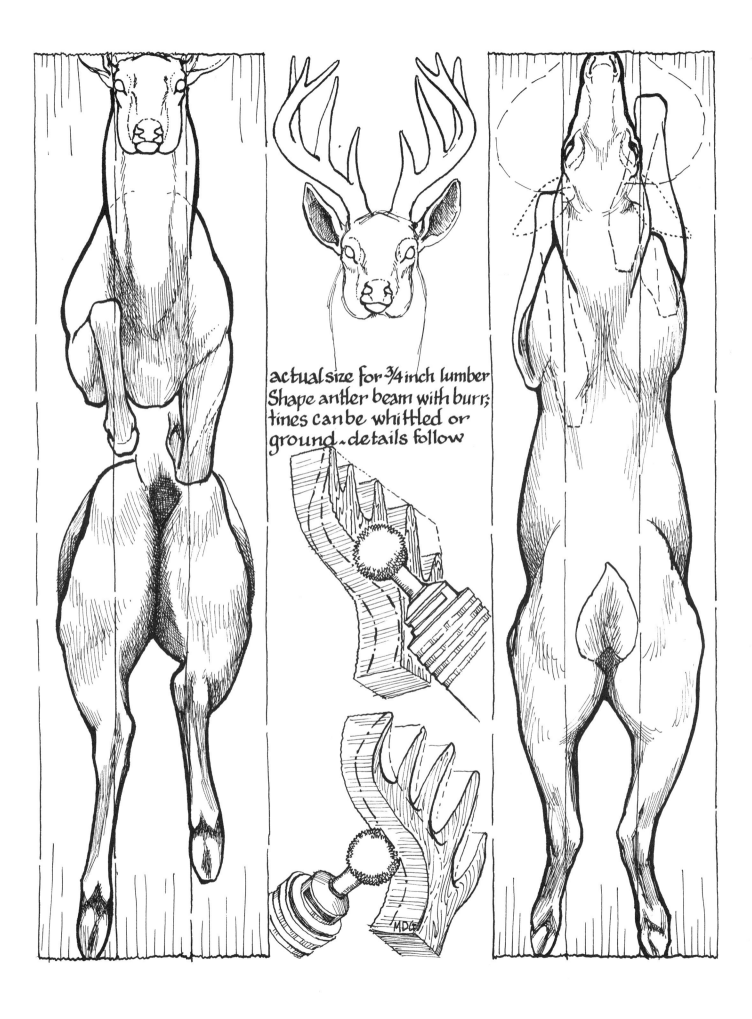

actual size for ¾ inch lumber
Shape antler beam with burr;
tines can be whittled or
ground. details follow

M.D.G.

3. The legs are to be done next. Before you recoil in horror, because the reinforcing struts inside the live buck's bones allow them to be more slender than your wood will permit, remember that wood can be quite "user-friendly" if treated with consideration.

Grinding gently can often stress the wood less than cutting/slicing with bladed tools because less material is removed at each pass, with less pressure.

On the standing buck, begin in front; on the jumper, do the stretched hind legs first. Those are the least complex forms. Your biggest ball-nosed burr will handle the outside waste removal from extended legs, but better switch to a taper to trim the insides. A buck's legs are bony and laterally flattened; even the backs of the hams should be rather flattened planes meeting in a wedge to illustrate the deer's streamlined quality.

The leaping buck's forelegs are most easily roughed with a dovetail burr.

Don't neglect the keeled aspect of the front chest and breastbone, or the obvious shoulder separation evident there.

4. From one end to the other—let's shape the tail! On the standing buck, the tail is slightly rounded over the bones forming its core, with tapering edges approximating the flaring hair. The leaping buck has the same shape flag, accented by a hollowed underside, particularly down at its dock, or base.

5. Before your consider the antlers and ears, why not finish off the surface? The final shaping and modeling can be done entirely with abrasives, though a more sculptural treatment is a combination of gouge facets and smoothed areas. The shallow fishtail gouge leaves the least disruptive texture, when used in the same direction as muscle mass or hair growth. The legs can be handsomely sanded into shape. The edge of an abrasive drum can give sufficient definition to toe cleats and dewclaws. Keep them unobtrusive!

Facial features can be omitted completely, if you'd rather. This can have a stunningly streamlining effect on a carving out of a loudly grained, dark wood.

Carve facial features if you'd prefer. You are very aware of their faces in chance encounters with live deer.

6. While antler carving is described with illustrations, amid the patterns; a word to the wise is in order. Even when carved out of sturdier hardwood, afterwards coating with cyanoacrylate (instant) glue for strengthening, antlers are extremely fragile under the best of circumstances. If you suspect that your buck's rack is liable to suffer—from the enthusiastic but less than careful dusting of a very arthritic little granny, for example—don't hesitate to make a more robust substitution. Satisfactorily durable antlers can be made from an armature of twisted brass wire coated with epoxy putty, painted to match the wood.

Now, about those ears . . . if you cut an ear out of a scrap of ¾-inch lumber, split it to make a pair. I cut mine with the saw to insure equal halves.

Should the small size be daunting, extend the "stems" at the base of the ears into more convenient, temporary hand-holds. You will probably find shaping the ears easier before attachment, because of the ready access you have to all areas.

Although on live animals, the ears are lined with abundant hair at their openings, to screen out insects, they are more attractive if carved "clean." If you opted for the sleeker, featureless face, however, extend this treatment to the ears; making only a suggestion of an indentation at the opening.

If this fellow fired up your "buck fever," he's quite likely to have the same effect on audiences elsewhere. The sculpturally impressionistic technique, once you learn it, is quite cost effective in terms of your time and labor investment, so can be quite a successful "market" piece. He could help support your hobby!

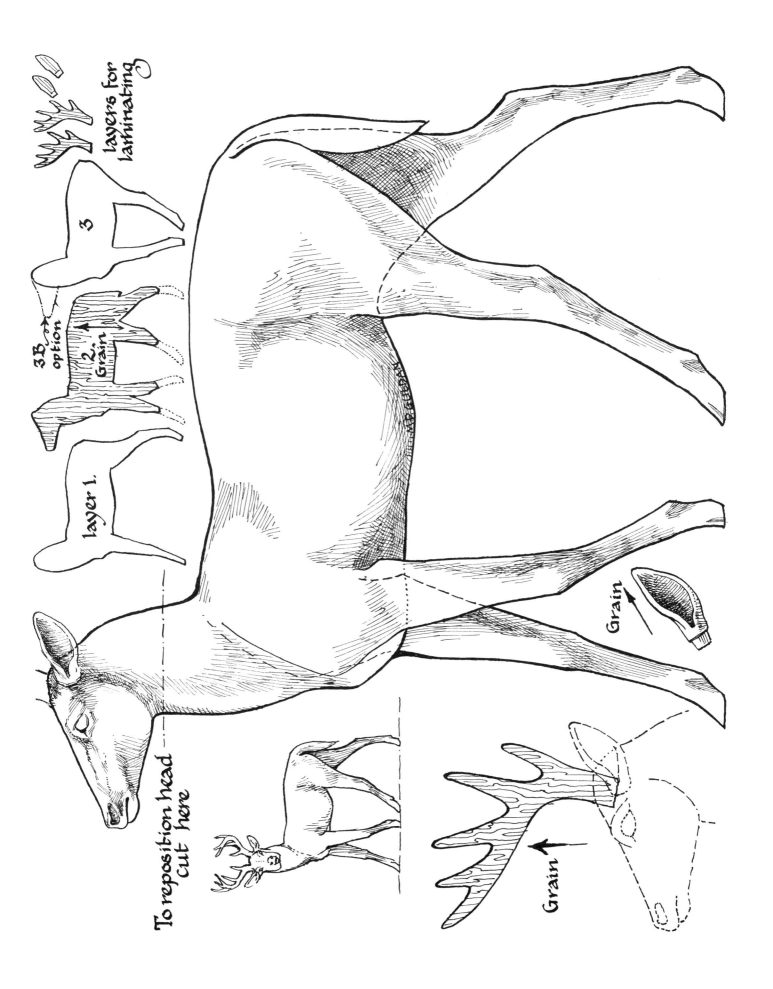

layers for laminating

3

3B option

layer 1.

2. Grain

To reposition head cut here

Grain

Grain

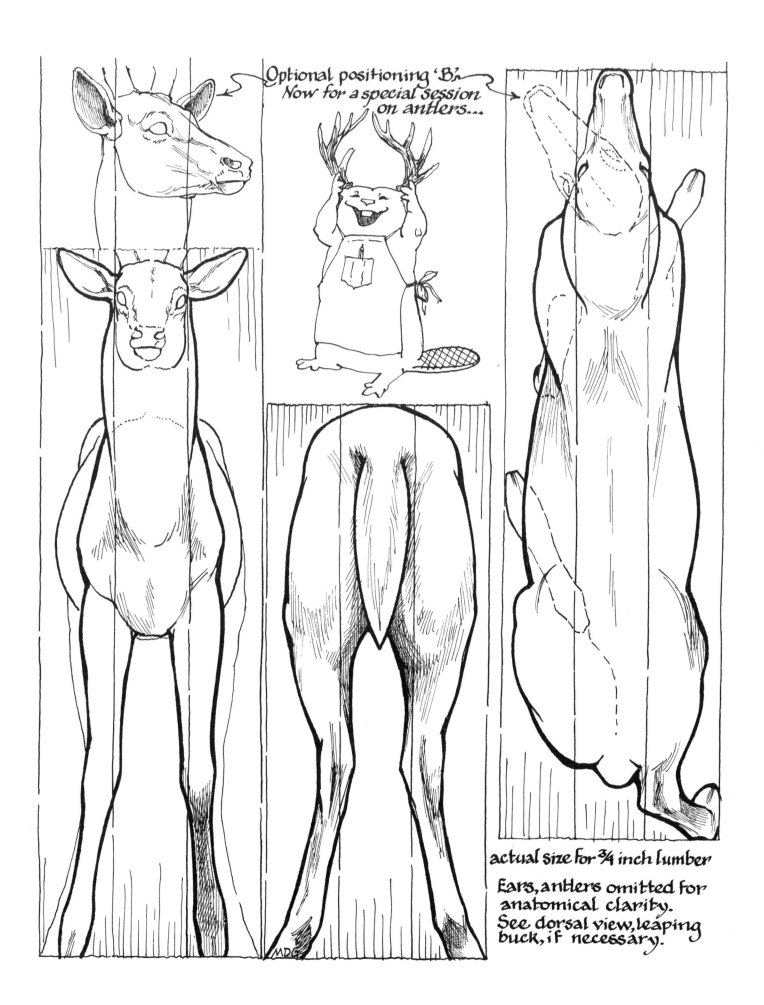

The techniques (or tactics!) you use to carve whitetail deer racks will work on all kinds of antlers. Because of their configuration, antlers will involve fragile cross-grain areas somewhere, so you may find that grinding is more feasible than whittling.

Plan for the base and beginning of the beam to have grain parallel to their direction. It will also strengthen the tines, since they will have lengthwise grain as well.

With a jeweler's saw, you can saw between the tines; these can be ground with a burr if the blank has been cut bulkier, straight across the tops of the tines.

Pencil-plan the largest curve in the beam that your lumber will accommodate.

Remove waste from inside, then outside of beam with a large round burr. Don't try to go too fast.

A piece of 2x4 about 6 inches long (sanded splinter-less) makes a convenient fixture against which you can support the tines while cutting them down to size.
Depending on your familiarity with the large round burr, you might do your preliminaries with it before shifting to abrasives for the final shaping.
Safer, though slower, is using abrasives exclusively on the tines.

For added control, try supporting your grinding hand by bracing a finger or two on your work base. Do the frail bits at low speed.

Work from beam to point, very gently. Support each tine from the back or underneath as you work on it.

To fit finished antlers to the head:

Drill sockets of appropriate size

Trim antlers' plug ends with a slight 'shoulder,' faint taper.

Tapered plugs allow more flexibility in positioning, yet will hold securely enough. Taper plug ends on antlers and ears. Attach ears when antlers' glue is completely dry).

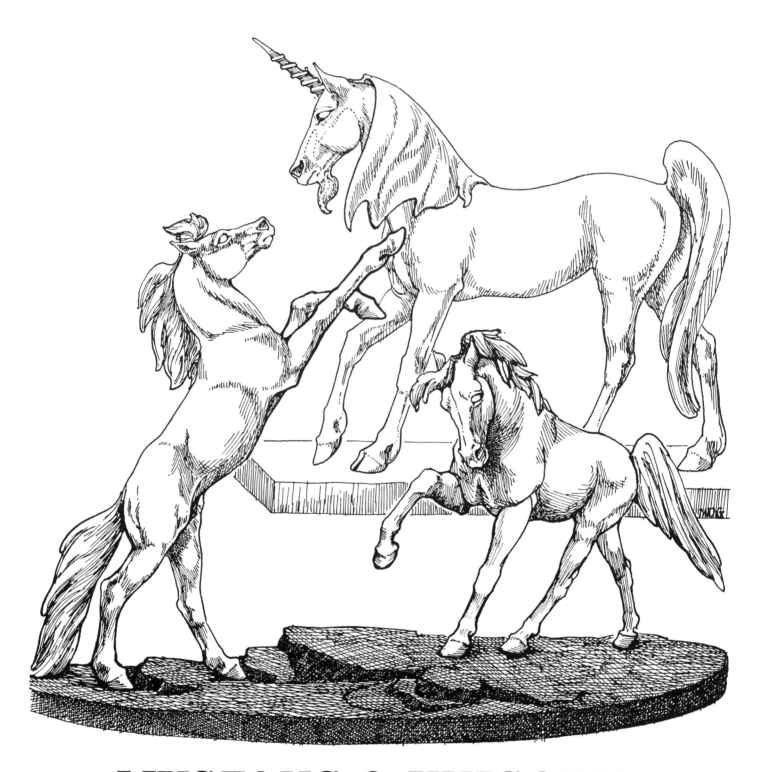

MUSTANG & UNICORN

Revive the spirit of the "Wild West" or enjoy a fantasy even older, from medieval Europe, when knighthood flourished, when you carve a mustang or a unicorn.

The mustang is not a native wild species, but the modern feral descendant of domestic horses originally strayed or stolen from the Spanish conquistadors who shipped them here. Compared to the cultivated saddle breeds to which we've become accustomed, mustangs look like something from a low-buck auction, usually shabby and undersized, stunted by the

rigors of their rugged life, often just a shade away from malnutrition.

Despite their unprepossessing appearance, they are hardy and enduring. The romance of their wildness is hard to resist; if you find the sight of a big buck exciting, double that thrill over an animal bigger than a buck, full of electrifying verve and bravado!

If you'd rather see your equine as a unicorn, you succumbed to the lure of ancient magic. The mythical beast seems to have appeared first in the Orient around the 4th century B.C., and arrived in Europe a couple of hundred years later.

It has been surmised that Crusaders returned from the Holy Land with stories of unicorns, generated by fleeting glimpses of large African antelopes. The largest, the Gemsbok, has particularly "horsey" proportions, including a stiff, upright mane and sweeping tail. It frequently trots or gallops rather than bounding away in a more deer-like fashion. Seen in profile, its "V" shaped pair of horns could easily be mistaken for a single horn, especially if sighted through shimmering heat waves as it easily outdistanced an overloaded warhorse.

The illustrators of contemporary zoo books, in which descriptions of unicorns were becoming immensely popular, did draw them from eyewitness accounts looking very much like antelope. With the market for "Bestiaries" mushrooming, artists became more and more fanciful as they transcribed their versions from each other, long removed from the originals. Eventually the unicorn evolved into the cloven-hoofed, horned horse familiar today.

Because of the similarity, let's approach the project from the horse's anatomical standpoint, noting the unicorn's digressions where needed.

1. In making up your blank for the pawing mustang, you are encouraged to include the tail as an integral part of the blank; however, feel free to make it an add-on should you feel it necessary. Be sure to include a generous base plug.

To counter the aggressive display of the pawing mustang, convert the rearing unicorn into a mustang by substituting the optional "B" forelock and tail portions. Omit the horn and beard, of course, and possibly the shaggy fetlocks, though the majority of mustangs are not clean-legged, and do sport hairy heels.

If you'd rather do a unicorn, you've got some interesting choices, including the pawing mustang, who can easily be adapted to a more fanciful animal.

The final unicorn pattern dramatizes a curious, magical power; by dipping his horn into waters poisoned by mineral seepage, or the taint of vipers drinking there, the unicorn purifies water for the gentle animals to drink, there is a second raised head position suggested for this body.

As proposed for the mustang's tail, turn any of these tails into plug-in units if you are uneasy about breakage. Certainly plan to make the horn an insert, possibly from some exotic material. While walnut, ebony or purpleheart are more likely choices, don't overlook some of the more far-fetched possibilities, not necessarily wood, like Lexan.

This is a tough clear plastic used in window glazing because of its improved resistance to leakage. Lexan is available at some hardware stores, sold for fixing storm doors, or as scraps from a friendly contractor using the thicker panels to protect church or store windows. It can be sawed and shaped with steel-bladed cutters in your flexshaft; be extraordinarily vigilant about wearing eye/face protection, as hot bits of plastic may get spun off. The stuff's gooey and rather smelly) when heated by your grinding; as a precaution against terminal gum-up, never use burrs, only cutters that can be easily cleaned once cooled.

As with other plastics, the roughed shape can be smoothed with steel wool and buffed with a little cloth wheel charged with the same jeweler's rouge you probably already use in tool sharpening. It's fun, and is an example that may start your own ingenuity percolating.

2. When you've constructed your blank and are drawing on the front, back and dorsal views, you'll find that the last unicorn's dorsal view is just a miniature because it is so similar to the pawing mustang.

The principal anatomical features characteristic of equines seen from above are also most frequently missed by the inexperienced sculptor, namely: the projection of the first cervical (atlas) vertebra, and the swell of the ribcage. The atlas vertebra forms the widest point of the neck, high, up behind the ears, contrary to supposition. One might expect the neck, seen from above, to be widest at its shoulder insertion. In profile, however, the opposite is true; the narrowest part of the neck is at the throatlatch, up behind the jaws.

From above, the narrowest point of the ribs is right behind the shoulder blades, with the ribcage springing to its widest just ahead of the hind legs. Seen in profile, though, the opposite is true again, with the wedge shaped barrel's widest point occurring just behind the forelegs.

3. Having made those key observations in pencil, let's make them a visual reality! As ever, begin roughing out from rump forward, using your largest gouge or ball-nosed burr. While the top of the rump is broad and rounded, the barrel is increasingly more peaked as you work toward the shoulder. Don't allow the shoulders to stay too mutton-whithered and chubby; they should progress trimly into the barrel.

Turn the rascal over and shape the underneath of his belly.

4. As you begin to establish the shape of the neck, pause to consider your intentions for the mane. The mustang, without the benefit of grooming, has a mane falling in stringy clumps on both sides of his neck. Burrs and brush keep it thinned. Plan to carve it like the wolf's rough fur. The unicorn, being the fantasy figure such as he is, can be treated to your most imaginative, swoopy, make-believe hair. If you stop to consider the characteristics of clean, straight, long human hair, you'll remember that it slides like a veil, rather than falling in corded hanks, which would carve up a bit too much like Medusa's snakes.

In either event, you won't need to leave a whole lot of extra wood. Instead, follow the shape of the neck, reserving a little extra wood for the mane.

The mustang stallion, unlike a cosseted domestic stud, has a negligible crest. His neck is very lean and limber, and can be arched to show considerable animation.

Indicate the taper of the head in a very general way.

5. To gain eventual access to the legs, do a little waste removal from the tail. It, too, will need to share in the mane's shaping scheme, so plan your roughing accordingly. You will want the mane and tail to match.

6. Now turn your attention to the legs. Mercy!

It may be helpful if you draw the outline of the feet in position on the bottom of the blank. Horses' legs are more angular, with definite joints and more obvious musculature than deer legs. If you haven't had that much modeling experience in that department, cut off the waste from the sides of the legs rather than square at first, following your pencil line. Afterward, return to develop the actual rounded shapes.

Most of these more delicate types of legs can be cut with burrs with less stress—to the wood fibers, if not to you, too. Use a large ballnose burr for the outsides of the legs, and a taper for the insides.

While sexing the mustang stallion is obvious, whether or not to do so on the unicorn remains a matter of choice. In antiquity, the engravings in the bestiaries were nearly always specifically male, equipping the chap like a stallion or ram. Now that so many illustrators are far from the farm, they seem rather vague in this matter, portraying asexual unicorns,

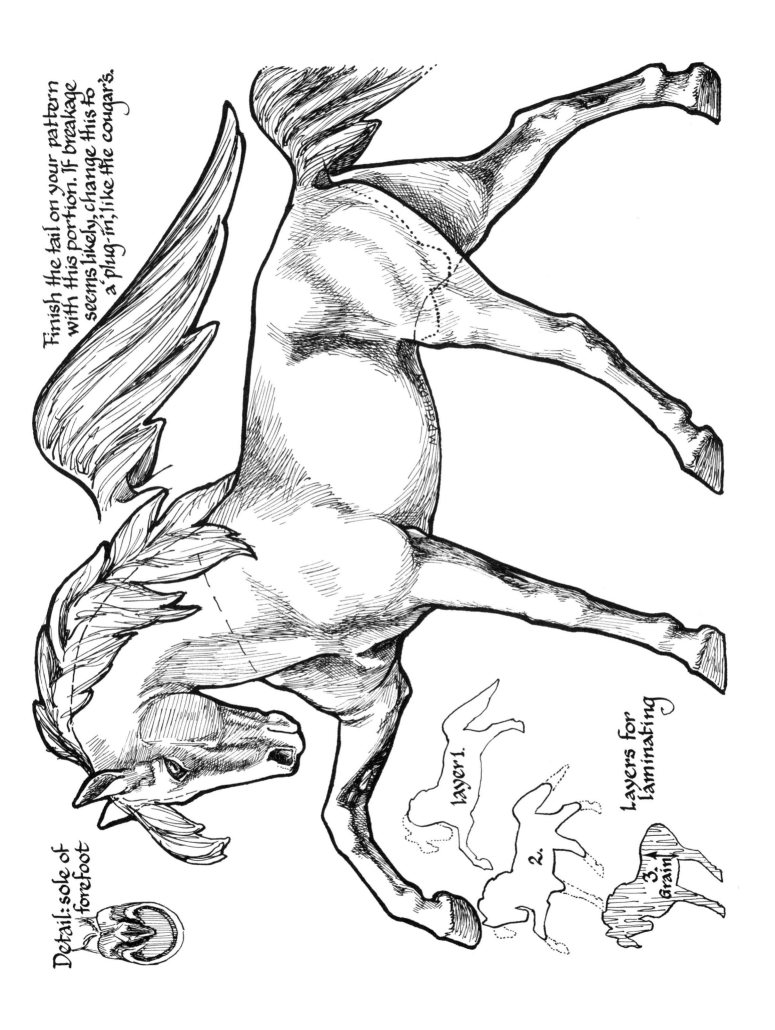

Finish the tail on your pattern with this portion. If breakage seems likely, change this to a plug-in, like the cougar's.

Detail: sole of forefoot

layer 1.

2.

3. Grain

Layers for laminating

M. PENUELAS

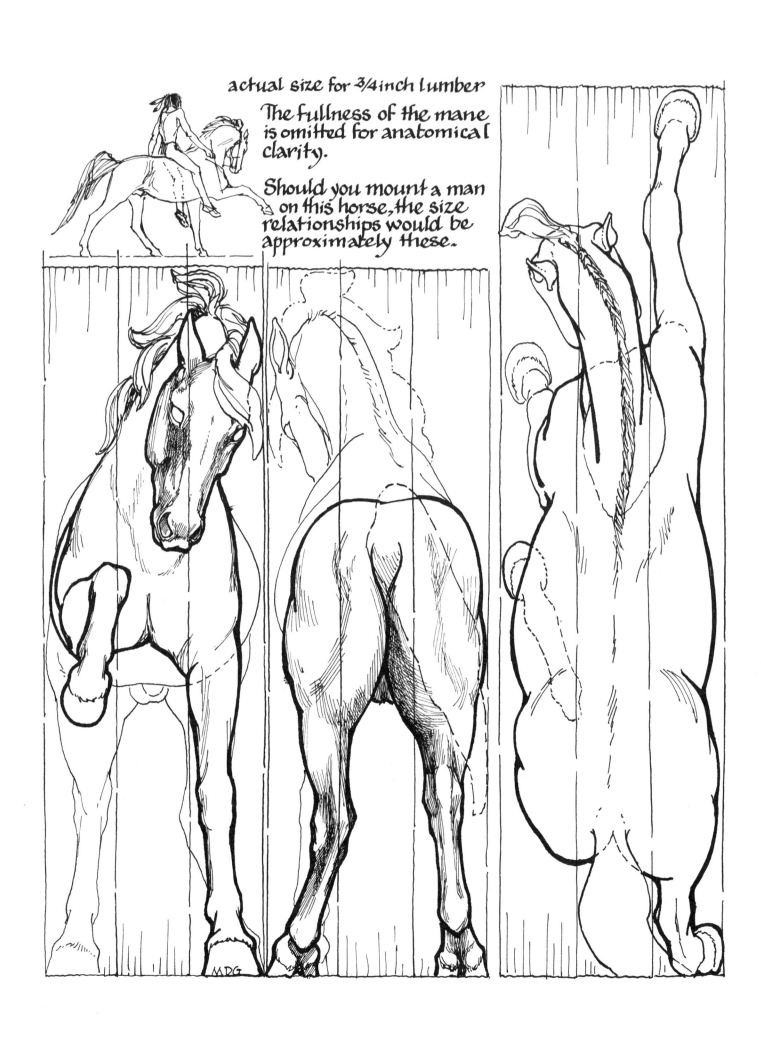

actual size for ¾ inch lumber

The fullness of the mane is omitted for anatomical clarity.

Should you mount a man on this horse, the size relationships would be approximately these.

probably because they don't realize that livestock is gendered.

7. The roughing-out done, it's time to work toward finished surfaces. As with the buck, an appropriately rugged texture for the mustang can be done with fishtail gouge strokes describing body areas and muscles. The unicorn can be done the same way, though can be made to look wonderfully ethereal if sanded quite smooth.

Shape the trunk and neck first, then detail the legs and feet. Abrasives can do much of their final modeling; the tiny "tee" cutter will grind the frog and hoof walls on the soles of the mustang's feet more easily than a V-tool will cut them. That V-tool will make a reasonable "stop-cut" to help you place the cleft between the cleats of the unicorn's hooves. The actual opening is best made with the corner of the fishtail gouge (in the same manner as the spaces between toes on the cougar's paws) to keep it from being too harsh. Check the detailed hoof instructions in the moose pattern for more specific directions.

When you've finished the feet, do the face. A lot of its spare boniness, on the lower muzzle especially, can be duplicated well with the smallest gouge. The cougar pattern outlines techniques to use on eyes and lips that can be successfully adapted to this project. The nostrils and ears are going to be pretty fragile, so better leave them until after the mane and tail have been textured.

8. While unadorned shaggy hair is in order for the mustang, don't get overexcited about doing the whole bit with your V-tool! Too many of those hard-edged, sharp little lines have harsh, distracting shadows. They leave ridges that look like snakes.

Refer to the wolf's fur detailing, and use your smallest gouge generously, but your V-tool very sparingly. Do the tail in the same way.

Have fun with the unicorn's swirly mane and tail! Since this is a fantastic creature, he may have the most naturalistic hair, like the mustangs, or he may be really exotic. Check photos of carousel horses for some interesting approaches to flying fantasy manes (many of their tails were real horsehair). Whichever treatment is given to the mane and tail, repeat on small scale for the unicorn's whiskers and fetlocks, to keep the piece unified.

9. Return to the nostrils and ears when the mane and tail have been done. The nostrils have illustrated directions amind the unicorn patterns; pencil plan their location carefully, with a merciless eye toward symmetry in all directions.

Yes, the ears are tiny, but can be shaped nonviolently, if slowly, with abrasives, and can be handily hollowed with the tiny sphere cutter.

Mustangs have wooly linings to keep insect pests and irritants out of the ear orifice, but a departure from nature, here, in making them clean-shaven as a show horse's, makes the mustang look very quick-witted and alert. Completed ears and nostrils can be made slightly more durable by being saturated with cyanoacrylate glue.

10. Now, that idea you've been brewing for a truly unique unicorn's horn . . . make it a reality.

An entertaining postscript, for those who enjoy photography, is to put overlong dowel pins (3 inches long, sharpened to a point on the bottom) into the feet and tail of the rearing unicorn, and take him out-of-doors to photograph before mounting on a permanent base. The sharpened dowels will peg him in the ground in a lively position while you take pictures. By choosing the scale of his surroundings, like a mossy bank in a wooded area, for example, you can make him look almost alive. The view through your viewfinder can be quite enchanting!

Then, nip off the excess dowel-length and mount the fellow on his base; after his magical moment, it may seem anticlimatic.

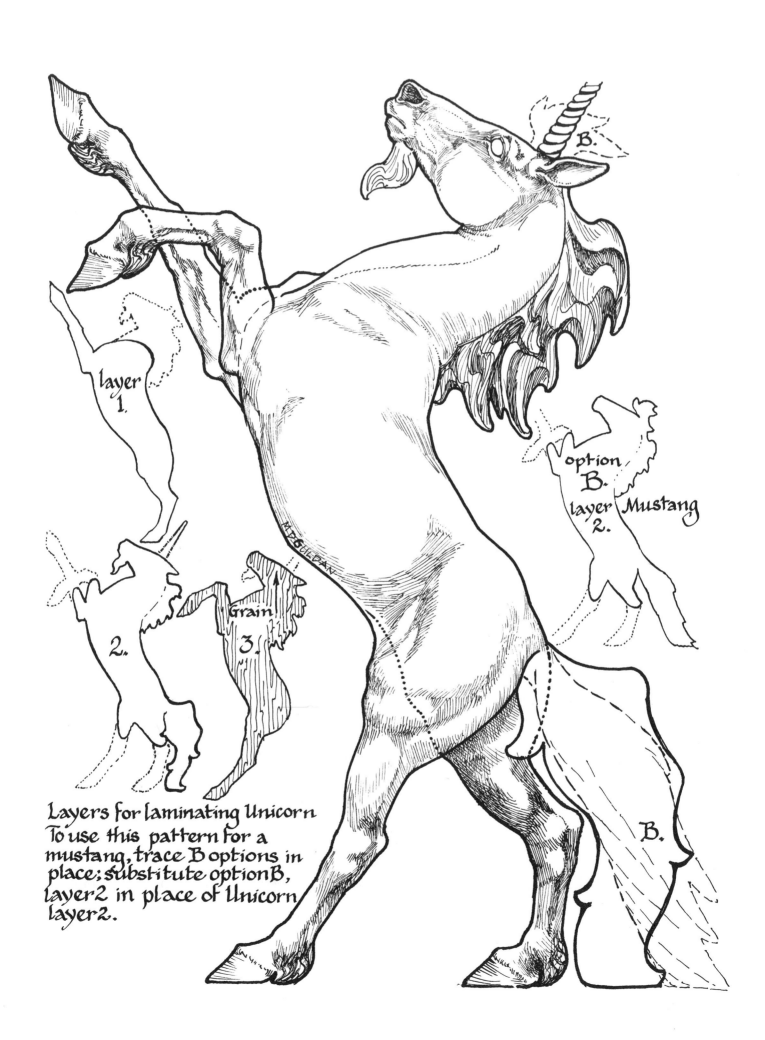

layer
1.

2.

Grain
3.

option
B.
layer
2.

Mustang

B.

Layers for laminating Unicorn
To use this pattern for a
mustang, trace B options in
place; substitute option B,
layer 2 in place of Unicorn
layer 2.

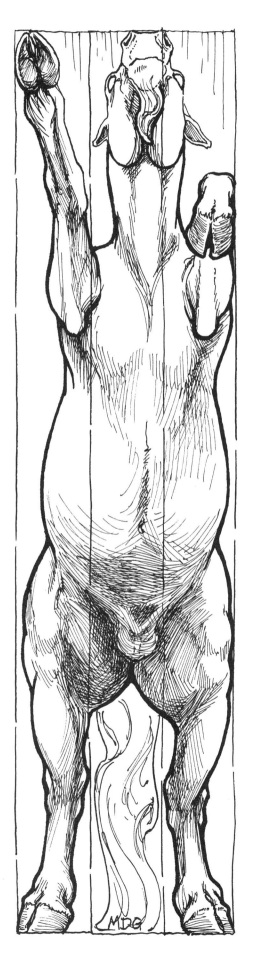

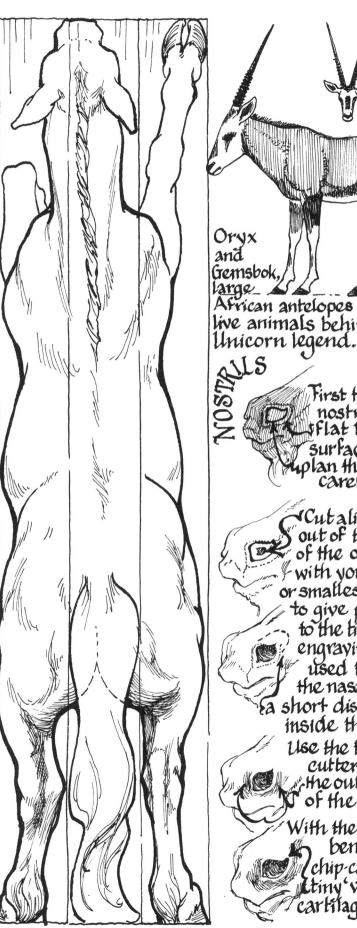

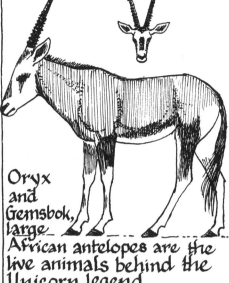

Oryx and Gemsbok, large African antelopes are the live animals behind the Unicorn legend.

NOSTRILS

First treat the nostril as a flat topped surface. Pencil-plan the opening carefully.

Cut a little nick out of the center of the opening with your 'V' tool or smallest gouge to give purchase to the tiny round engraving cutter used to hollow the nasal cavity a short distance up inside the head.

Use the tiny round cutter to refine the outside edge of the nostril.

With the tip of the bench knife, chip-carve the tiny 'v' at the cartilage corner.

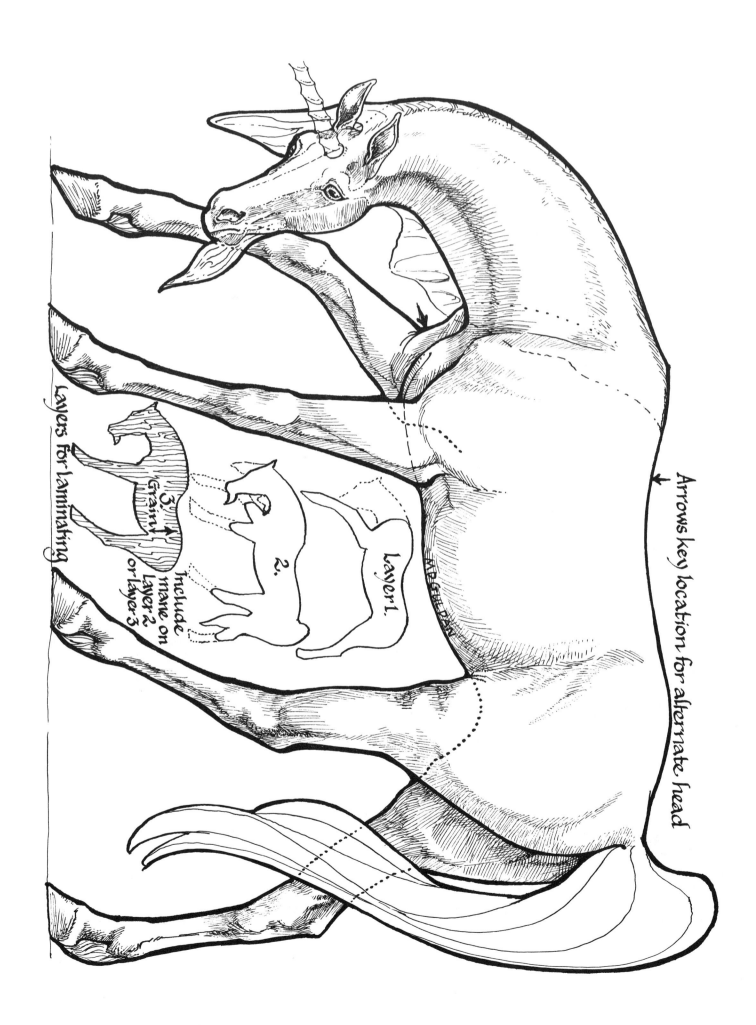

Arrows key location for alternate head

Layers for laminating

3. Giant

Include mane on Layer 2 or Layer 3

2.

Layer 1

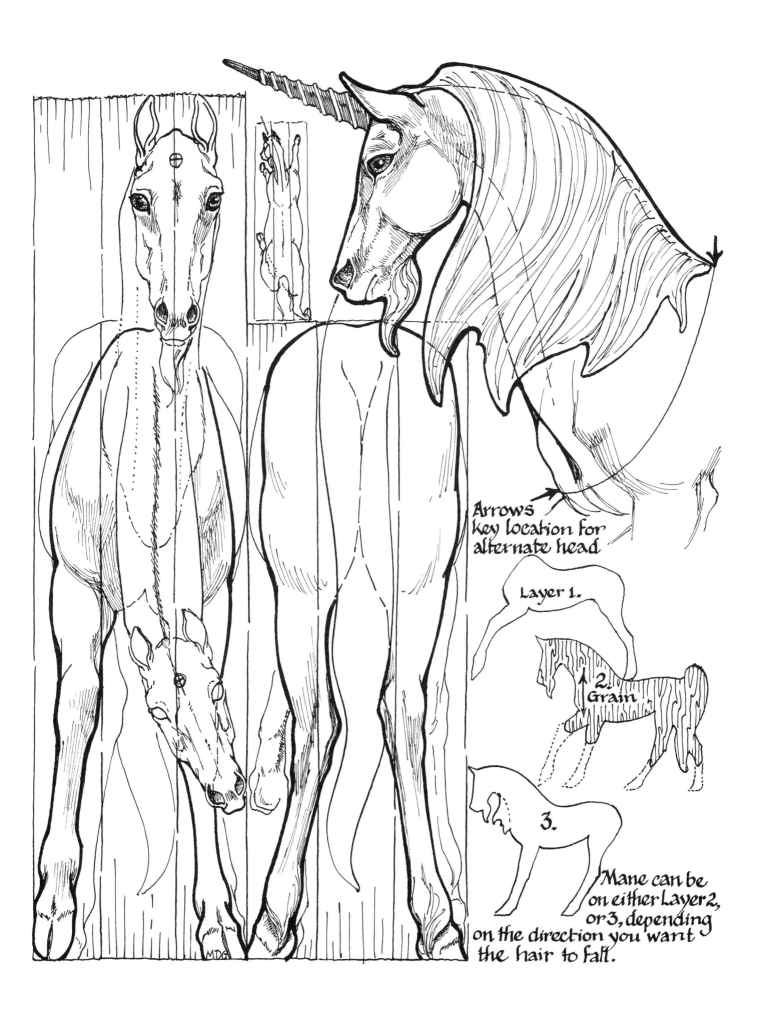

Arrows
key location for
alternate head

Layer 1.

2. Grain

3.

Mane can be
on either Layer 2.
or 3, depending
on the direction you want
the hair to fall.

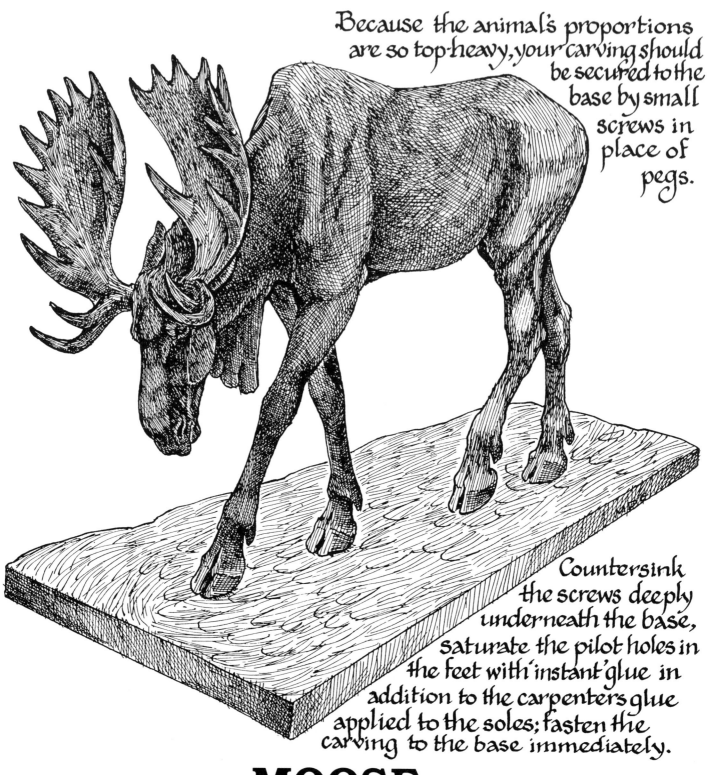

Because the animal's proportions are so top-heavy, your carving should be secured to the base by small screws in place of pegs.

Countersink the screws deeply underneath the base, saturate the pilot holes in the feet with 'instant' glue in addition to the carpenter's glue applied to the soles; fasten the carving to the base immediately.

MOOSE

AS the largest surviving member of the deer family, the moose, measuring occasionally 7 ft. 9 in. at the shoulder and weighing 1400 lbs., makes up in awesome size whatever he may lack in facial refinement. His antlers, perhaps his most impressive feature, sometimes sporting a 6 ft. "wingspan," should not be as difficult to engineer as the flattened spirals of the Bighorn's headgear. The finished carving can be interestingly mounted as a single figure,

perhaps in a confrontation with the other moose, or harassed by wolves. While the wolves would never attempt to molest a bull of this size and vigor, they would certainly exchange threats of violence with him, should their paths incidentally cross.

Let's get this adventure underway!

1. When you construct your bank for the aggressive moose, be sure to include the two extra layers for the head and neck, in addition to the four body layers. It is intended that the ears, flattened against the neck, be carved from the head and neck unit, not added on. If you plan to do the ambling moose as an isolated specimen, you may prefer to make plug-in ears as you did for the deer, in order to focus them forward in suspicion.

Draw onto the blank the front, back and dorsal views, as well as the soles of the feet on the bottom of the leg blanks, to establish position.

Before you actually get to hewing away at the waste areas starting, as always, with the rump, notice some anatomical particulars that will stabilize immediately. While the muscle over the hips is full and rounded like a horse's, when seen from the rear, the sides of the rump, between hip and hind point of the pelvis are quite flat. The dorsal view shows clearly this wedge shape, so characteristic of deer. You will not want the backs of his hams to be left too rounded, inadvertently, or he'll look like a horse.

Notice the asymmetry in his hip heights, caused by tissues shifting at each stride. The weight-supporting leg causes that upward thrust of the hip, making that side higher, as the opposite side drops momentarily to pivot forward, in anticipation of landing the next footstep. This is also true of shoulders and forelegs; the leg holding the largest load is the suspension point, from which the rest of the body hangs.

Check the dorsal view of the lunging moose before you start to carve to ascertain the direction and compression of his ribcage, otherwise you may get the mistaken notion that he's just a fat little rascal. Recall your observations of domestic cattle fighting, if you've had that opportunity, and ponder the tactical use of horns to do battle. It will bring your carving to life.

To fight most effectively, the aggressor will arch his back upward, to bring the power of those driving hind legs farther underneath his weight, and as close to the center of action as possible. He maximizes their punch by crouching, lowering his center of gravity. You may have seen domestic bulls drop to their knees to keep gravity on their side, pulling their adversary down onto the swift uppercut of their horns.

Our moose has hunched and crouched, so that his ribcage is pinched on his left by the hind leg striding forward to pivot and punch. On the opposite side, as well as being compressed from end to end by his arched backbone, his ribcage is thrust out along its right rear edge by the lateral twist of the spine.

Imagined in cross-section, as if sliced in half across its width, the ribcage is egg shaped; narrow at the top, broad at the bottom. Nowhere is it uniformly round as a storage barrel. Think of this as you prepare to shape these areas.

Let's get on with the roughing-out now, using the large ball-nosed burr or gouge. Begin at the back of the rump, noting its slab-sided, wedge shaped character already described. As you start forward, don't forget how relatively narrow the topline of this animal should be, starting with the ovoid shape of ribs, merging into a hollow behind the shoulders. The shoulders, especially when seen from above, are spare and relatively narrow.

The neck is quite narrow as well, and very short; to graze, this animal must drop to his knees to reach the grass. Remember that his ears are intended to be carved from the wood of the head and neck, since they are laid back so tightly; be sure to leave wood enough for them. Don't neglect the protrusion of the first cervical vertebra, just behind the head. It is a

significant, though often forgotten feature in hoofed critters, and in many four-legged folk with paws, as well. Check the horse pattern for specifics, though the moose's will not be so prominent, nor have such heavy ridges of muscle down either side. His neck is very lean, though will be shaggy, with his growing winter coat forming sort of a mane along the back.

2. Flip the fellow over to finish out his ribcage, which is quite narrow behind the elbows gradually widening to its largest diameter a little ahead of the hind legs. There is a very slight depression down the center of the belly, over the breastbone, into middle of the abdominal wall, stopping at the navel, which occurs at the same location, comparatively, as a human's, equidistant from the end of the ribs and beginning of the hipbones. This is a technicality you may include or ignore as you see fit. The median hollow is a realistic inclusion when visible, should this carving eventually be displayed on a mantel or bookshelf.

3. Having generally established body contours, go to work on the legs. In the pattern, they are pictured in sturdier proportions than they actually occur on the live animal, presuming that this is probably as slender as your choice of wood will allow. At the season when this bull would be sporting a full-grown rack of antlers, he would also be starting to grow his winter coat, so his legs will not be showing much muscle definition.

To prevent his looking bench legged and stiff, be sure that his hocks come rather close together in back, enabling him to step through brush with greater efficiency. His forelegs should be a bit calf-kneed, a little offset below the knee, rather than perfectly straight.

4. When the legs have been roughed out, work on the head, reducing the width of the blank along the sides of the face, which tapers very little. There is a good bit of waste along the front of the aggressive moose's face to allow you some leeway in positioning his head, if you want the gesture to be very specifically aimed.

5. With this, your animal should have pretty well taken shape, so is now ready for final modeling. A most suitable craggy texture can be gotten by using gouge strokes, in the same direction as hair or muscles grown, starting with the fishtail on broader body areas. Follow with the small gouge, modeling lean and bony areas, like the neck and face, and upper legs. Use the smallest gouge particularly on the face and ears, which may have their edges suggested, but do not need to have their wooly interiors hollowed.

The nostrils can be done with the tiny round engraving burr, adapting the procedure used to do the horse's muzzle. The cougar pattern will supply a refresher course on techniques for lips and eyes.

In order to give the moose his sullen and speculative expression, carve his eyes rather shallow and somewhat flatter than you may have done on the horse or deer. The deeper your cut defining the curvature of the eyeballs and edges of lids, the darker the shadow, and the more thoughtful, reflective and intelligent those eyes appear. Deep and thoughtful eyes would be highly inappropriate for this animal, whose expression is one of belligerence, not intelligence. While it seems like the ultimate presumption to anthropomorphize the moose his way, as an artist, you are describing this subject with every cut of your tool. Those cuts must be as carefully calculated as a story teller's choice of works.

6. The smallest gouge, and not the V-tool, will hint at the slight muscle definition in the legs and haunches. The lower legs can be shaped with the abrasives and tools detailed in the illustrated practiculars on doing hooves.

7. Last of all will be that splendid set of antlers. Yes, there are bound to be fragile, cross-grain areas in shapes like those, but they can be managed. Refer to the illustrations, and rejoice in the fact that all antlers are as individual as fingerprints, snowflakes, signatures . . . and woodcarvers.

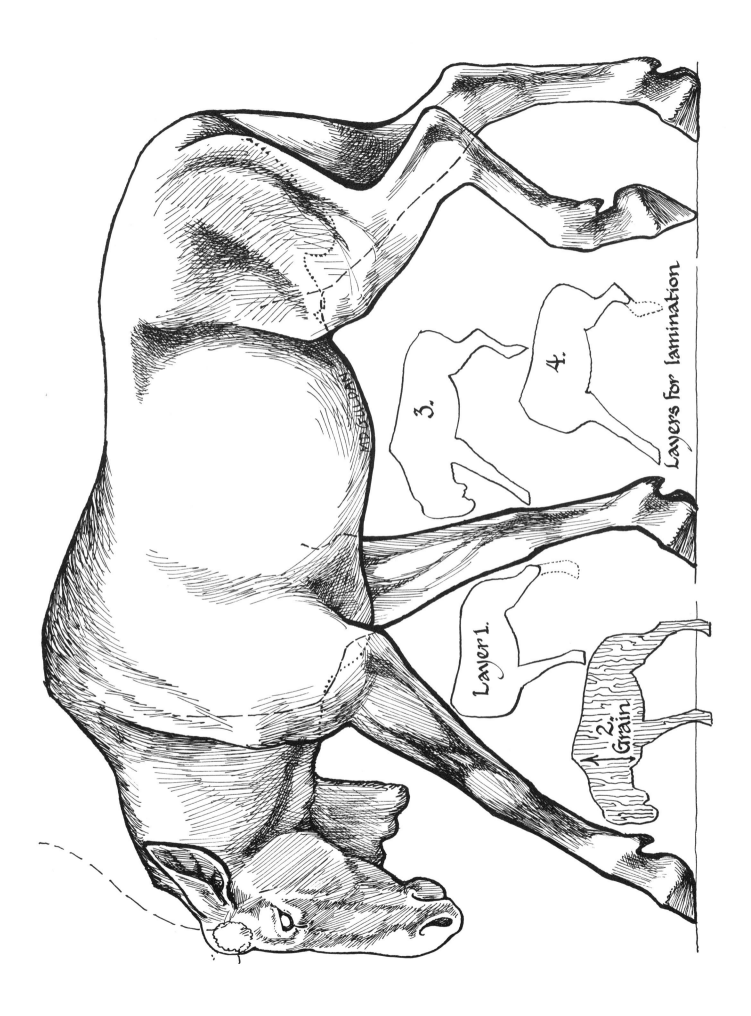

Layers for lamination

3.

4.

Layer 1.

2. Grain

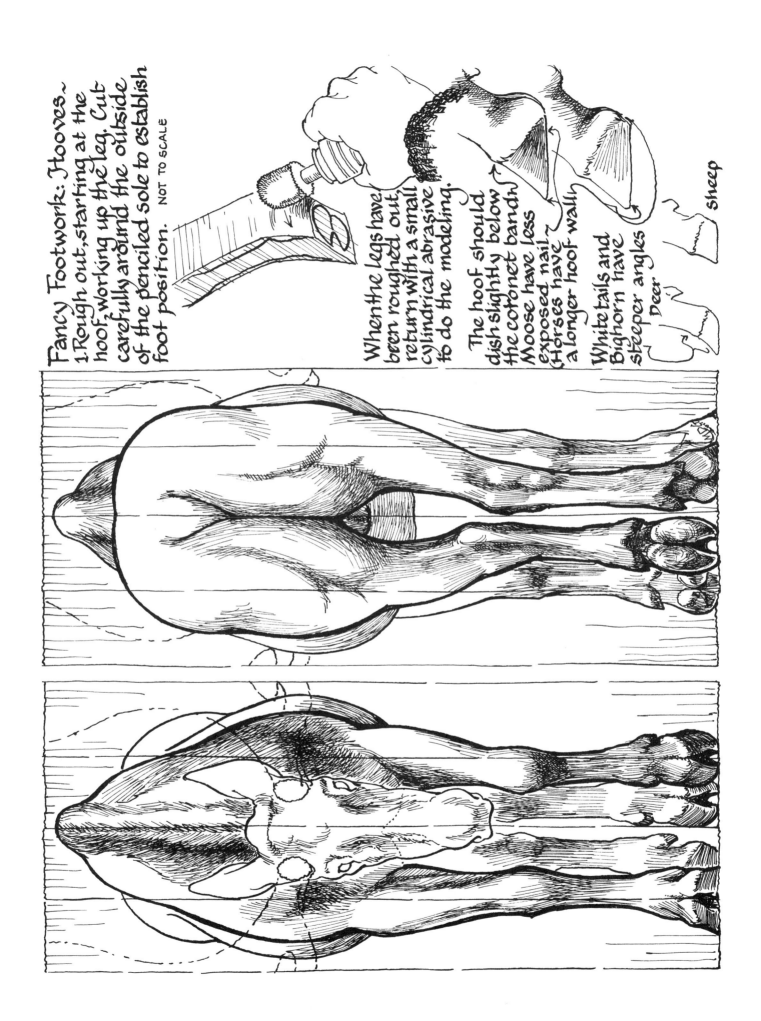

Fancy Footwork: Hooves~
1. Rough out, starting at the hoof, working up the leg. Cut carefully around the outside of the penciled sole to establish foot position. NOT TO SCALE

When the legs have been roughed out, return with a small cylindrical abrasive to do the modeling.

The hoof should dish slightly below the coronet band. Moose have less exposed nail. Horses have a longer hoof wall.

Whitetails and Bighorn have steeper angles

Deer

Sheep

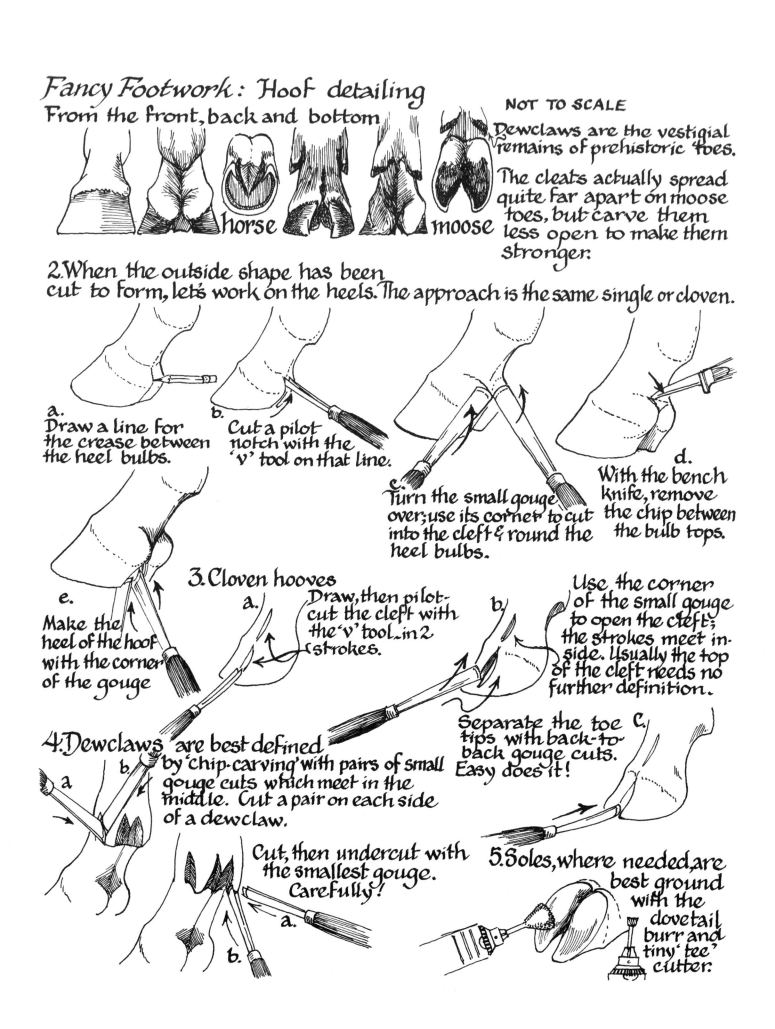

Fancy Footwork: Hoof detailing
From the front, back and bottom

horse moose

Dewclaws are the vestigial remains of prehistoric toes.

The cleats actually spread quite far apart on moose toes, but carve them less open to make them stronger.

2. When the outside shape has been cut to form, let's work on the heels. The approach is the same single or cloven.

a. Draw a line for the crease between the heel bulbs.

b. Cut a pilot notch with the 'v' tool on that line.

c. Turn the small gouge over; use its corner to cut into the cleft & round the heel bulbs.

d. With the bench knife, remove the chip between the bulb tops.

e. Make the heel of the hoof with the corner of the gouge

3. Cloven hooves

a. Draw, then pilot-cut the cleft with the 'v' tool in 2 strokes.

b. Use the corner of the small gouge to open the cleft; the strokes meet inside. Usually the top of the cleft needs no further definition.

c. Separate the toe tips with back-to-back gouge cuts. Easy does it!

4. Dewclaws are best defined by 'chip-carving' with pairs of small gouge cuts which meet in the middle. Cut a pair on each side of a dewclaw.

a.
b.

a. Cut, then undercut with the smallest gouge. Carefully!

b.

5. Soles, where needed, are best ground with the dovetail burr and tiny 'tee' cutter.

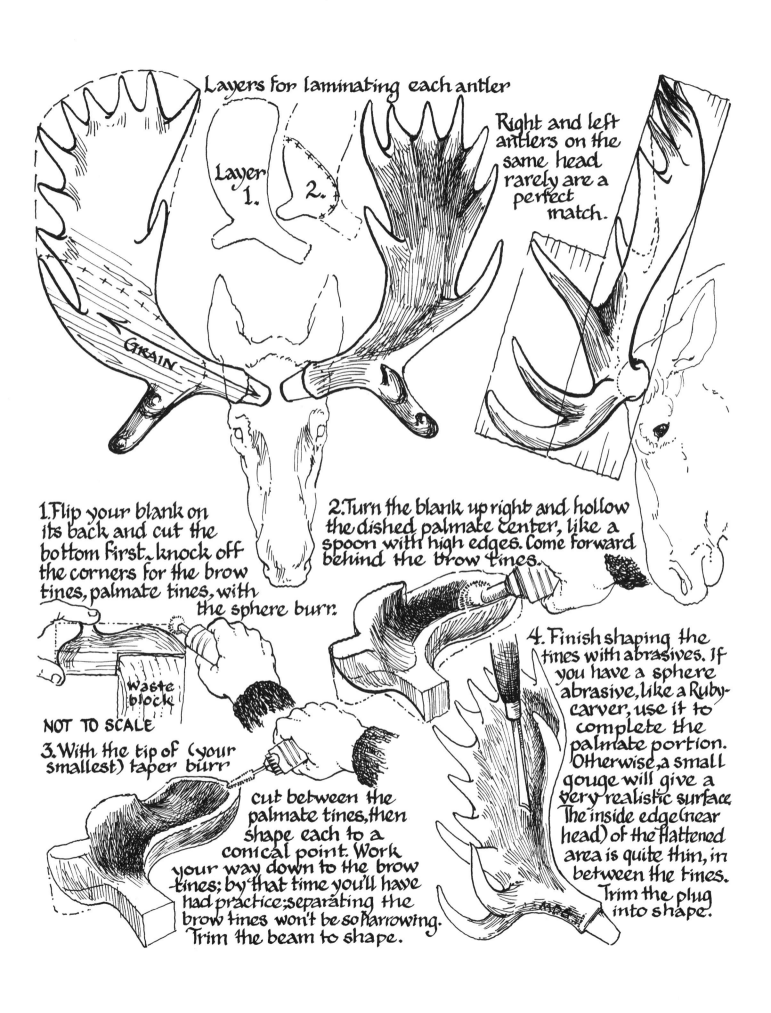

Layers for laminating each antler

Layer 1. 2.

Right and left antlers on the same head rarely are a perfect match.

GRAIN

1. Flip your blank on its back and cut the bottom first. Knock off the corners for the brow tines, palmate tines, with the sphere burr.

waste block

NOT TO SCALE

3. With the tip of (your smallest) taper burr cut between the palmate tines, then shape each to a conical point. Work your way down to the brow tines; by that time you'll have had practice; separating the brow tines won't be so harrowing. Trim the beam to shape.

2. Turn the blank upright and hollow the dished palmate center, like a spoon with high edges. Come forward behind the brow tines.

4. Finish shaping the tines with abrasives. If you have a sphere abrasive, like a Ruby-carver, use it to complete the palmate portion. Otherwise, a small gouge will give a very realistic surface. The inside edge (near head) of the flattened area is quite thin, in between the tines. Trim the plug into shape.

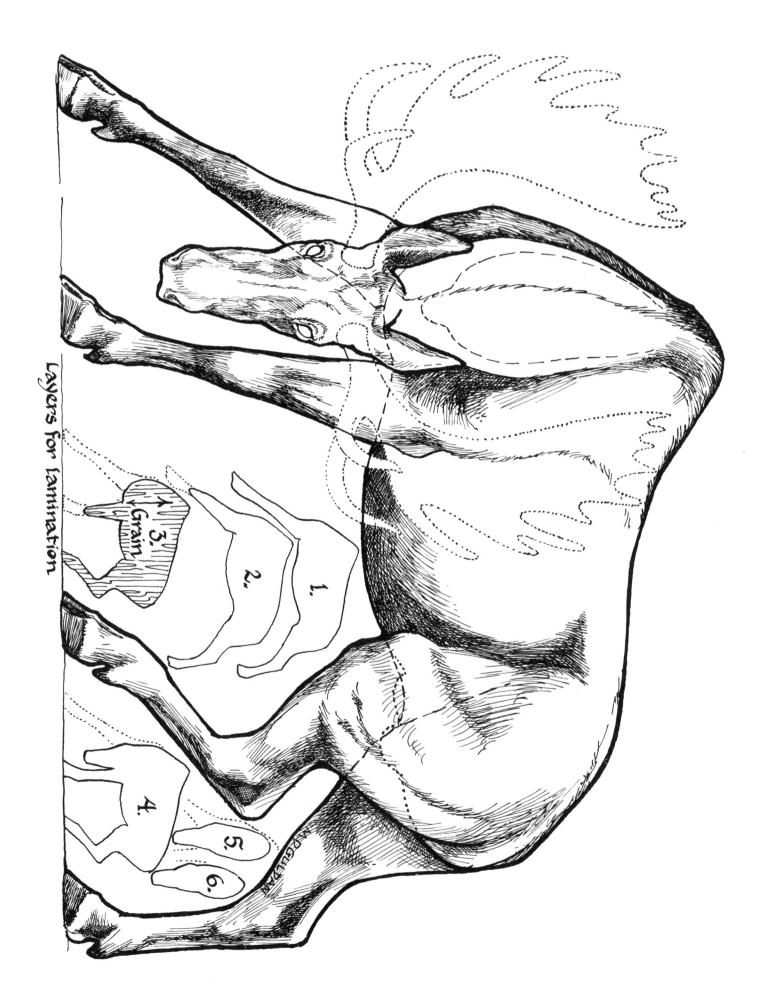

Layers for Lamination

3.
← Grain

2.

1.

4.

5.

6.

MARCHEPAN

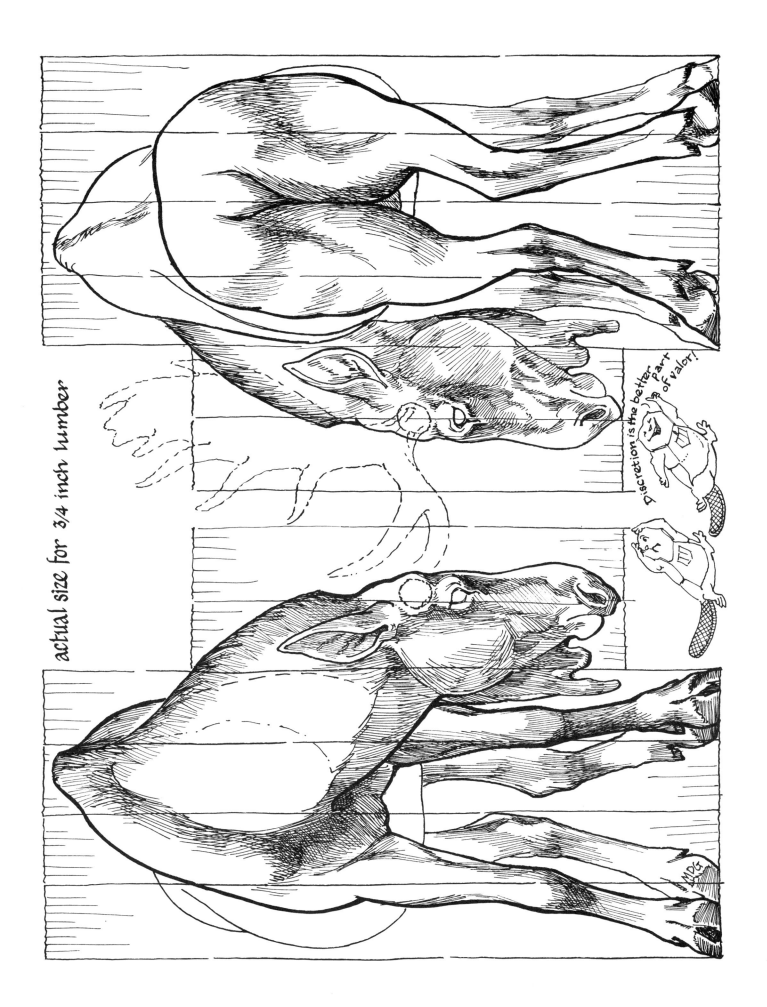

actual size for 3/4 inch lumber

Discretion is the better part of valor!

PAINTING, STAINING, SEALING

Whether to paint or stain or to simply seal your carving is your choice, governed by your personal preference and your intentions for the piece.

If this carving is purely for your own pleasure or to give as a gift, you are certainly entitled to finish it any way you please.

Carvings intended for shows or marketing are usually better stained or left natural color, protected by a transparent finish. Judges justifiably reason that paint can 'hide a multitude of sins,' namely non-wood repairs or fabrications that are not carved out of wood; they may be a bit suspicious of painted carvings of subjects other than birds.

The customer who buys wooden sculpture usually finds the unobscured medium as appealing as the subject itself. They like for the wood grain to show. Despite the fact that much of the classical Greek sculpture we so revere in its currently weathered condition originally was vividly polychromed, modern market trends indicate patrons' preference in general, for natural color in anything considered sculpture.

This is your work, though, so if you want color, by all means, color you shall have!

Color is fun, and you have several options. First, do your research. Trace the pattern on a clean sheet of white paper to be used as a color chart, then head for your research resources.

The ideal is a live model, noting the unavailability of some species, your alternative is to seek what is in print. Nature, wildlife and hunting magazines are excellent sources of pictures. Locate photographs and not artist's renderings where ever possible, because you will want to be responsible for your own accuracy in editing what you decide are extraneous details. That artist may not have been as careful as you are.

National Wildlife, International Wildlife and Field and Stream are some most helpful periodicals. Check on Smithsonian, which has some excellent features on animals from time to time. Don't discount nature magazines for children; National Geographic World, and National Wildlife's Ranger Rick, and Your Big Backyard have superlative, large detailed photos. You will find your own proliferation of National Geographics absolutely indespensible.

Besides the magazines available in your local library, scout the natural history and zoological sections. Look for materials on the geographical areas where your subject might be found; books on national parks often include pictures of animals protected there.

Once you've located some useful pictures, let them help you to map out colors and patterns on your diagram.

If you can countenance being caught using such equipment, one of the cleanest, most portable, comprehensive and convenient color mediums is a large (64 count) box of kiddie's Crayola crayons! The spectrum is wide and well balanced, especially in the earthy animal colors you'll need most. These colors translate well into oil or acrylic paints because many of them have the same names. You can build very realistic color by 'glazing' the old master painters' technique of adding successively darker tones on a light base to achieve the required shade.

When you have identified the colors and have mapped out the pattern on paper, pencil the pattern areas onto your carving if you need specific directions, and decide on the color medium.

Depending on your experience and preference, you may want to paint your carving in artists' oils. These over a coat of plaster gesso were used extensively on wooden statuary from the Middle Ages to the early 19th century.

While they are slower drying, they do allow you time for blending and overpainting. They are most effective when used as more of a stain, thinned with turpentine until brushstrokes are no longer visible and they sink into the surface. Over time, they will change color somewhat as the wood underneath darkens with age. The preventative measure of isolating the paint on the surface by first applying an oil-compatible gesso, sacrifices the crispness of your carving.

Artists' oil paints used as stains dry to a matte finish, seldom needing a protective overcoat. Varnish would make them distractingly shiny.

Now, let's outline a list of basic colors and their uses.

Oils

Black (maybe labeled Ivory Black)	Prussian Blue
White (Titanium White)	(Sap) Green
Cadmium Yellow	Raw Sienna
Yellow Ochre	Burnt Sienna
Cadmium Red	Burnt Umber
Alizarin Crimson	Raw Umber

If your choice of yellow or red has 'pale,' 'medium' or 'deep' added to its name, choose the darkest, as it will be the most vivid. The chemical names on your black and white are, for these purposes, unimportant.

Stains

If the wood you used is quite light in color and grain figure, a stain can dramatize your modeling as well as make the wood look more flamboyant. There are some excellent stains in a wide variety of vehicles available, but most were intended for furniture rather than carved figures. The color uniformity that makes a piece of furniture cohesive, when applied to a carving may be a bit too bland and characterless, too like a ceramic glaze.

The custom colors you mix for yourself from artists' oil paints and a compatible oil-resin finish bypass the uniformity if blended a brushload at a time so that the proportions are never identical. The vague irregularities you produce will be more like the character of dramatic hardwoods and will look less artificial than the homogenized commercial furniture stains.

No stain will ever equal the depth and luminosity of actual specimens of the more dramatic hardwoods, but they can liven up some otherwise nondescript species.

Here are some recipes to give you a starting point to which you can add your own concoctions.

The units of measure, inches and fractions of inches, do sound improbable, but are to aid you in getting the best proportions. This is the amount you squeeze from the tube onto the edge of your palette tray.

These are oil based stains used to saturate raw wood, a messy project, so be sure to have lots of newspaper underneath. Your carving should not be mounted on its base yet.

Fold yourself a little tray palette from aluminum baking foil; raise one side slightly by putting it atop a couple of sheets of newspaper folded into a pad. Squeeze your colors along the high side; puddle your solvent/vehicle in the low end.

Flat, chisel-tipped white bristle brushes for artists' oils and acrylics handle this job best. The ½ inch size is most agile, and easily cleaned afterward.

Dip the corner of the brush into each of the colors, pulling them down to mix at the edge of your solvent puddle. When they are fairly fluid, apply the brushload to your carving, painting in the same direction as the grain. Your strokes may blend the colors further as you paint, but some subtle marbling, where the colors were not completely mixed in places, is desirable.

Ebonized Wood

From tubes of artists' oil paints squeeze:
 1 inch of black
 ¾ inch of raw umber
 ½ inch of prussian blue
Mix with enough turpentine to get the consistency of milk, but test on a piece of scrap to be sure the mixture will sink without looking frosty or greyish. If it looks frosty, add more black.

Brush slowly enough to get good penetration, paying special attention to nostrils, eyes and ears that could be overlooked. Work from one end to the other, being sure to turn the piece over to get the underside thoroughly. Really soak any end grain areas.

As soon as the paint has sunk into the surface, so that it is not slippery to touch, apply oil finish. Be sure to do this over a lot of newspaper because some of the pigment will be floated off with the excess oil finish. Pick it up with your brush and put it back on if you like.

The idea is to use the oil finish to soak the pigment deeper into the wood, so your brushstrokes should barely skim the surface.

Let this dry for 12 hours (overnight).

Depending on the porosity of your particular wood, or in places where there was exposed glue, there may be pale areas. Mix some more of your color recipe, floating it in oil finish this time, instead of turpentine. This will cause no problem if you'd like to give the entire piece another coating.

Let this touch-up coat dry thoroughly, usually about 24 hours.

Seal with a coat of oil finish, absolutely saturating your carving; in end-grain areas, keep flooding until no more will soak in.

Watco recommends a 30-minute wait, then wiping off any shiny wet spots with a clean, dry, lint-free rag.

Mahogany

From tubes of artits oils, squeeze:
 1 inch of burnt sienna
 ½ inch alizarin crimson
To the upper side of the carving, you may want to include a touch of yellow ochre; to the underside, a touch of burnt umber instead of the yellow ochre.

Proceed as with the ebonized wood, mixing your colors in turpentine, and oil finishing in the same fashion.

Walnut

From tubes of artists oils, squeeze:
 1 inch of burnt umber
 ¾ inch of burnt sienna
At random, add a touch of yellow ochre well blended into the brown tones.

Substitute these colors in place of the black combination in the ebonized wood recipe. The procedure is the same.

The actual amount of stain mixture needed to soak a carving varies greatly with the porosity of the species, and that individual piece of wood. Keep mixing small amounts of stain so they will not be eactly alike; you want the irregularity.

Acrylics

Artists' acrylic paints are quick drying and give you the convenience of cleaning up your brushes afterward with tap water. Because the pigment is floated in jellylike plastic, these colors do not sink into the wood as quickly as thinned oils, or transparent watercolor. A bright, glossy surface coating, rather like a ceramic glaze is their forté.

Spray your carving with a light coat of clear lacquer, then sand off any 'fuzz' raised in the grain, following up with another light coat of clear lacquer and further sanding if needed. Seal with a light coat of lacquer and draw on the color pattern in pencil, as required.

Acrylics can be mixed on your palette like oils, though they are a little thicker consistency straight from the tube and need a slight thinning with water to avoid leaving corduroy brushstrokes which 'bury' your carving.

They are best protected by a final coat of clear lacquer.

Acrylics

Black (may be labeled Mars Black)	Phthalocyanine (Phthalo) Blue
White (Titanium White)	Permanent Green
Cadmium Yellow (medium)	Raw Sienna
Yellow Ochre	Burnt Sienna
Napthol Red (or Napthol Crimson)	Burnt Umber
is equivalent of the 'warm'	Raw Umber
cadmium red in oils.	

Again, a qualifier like 'pale,' 'medium' or 'deep' in the name of your yellow or red is the measure of color intensity; choose the darkest available.

Wax

Following the last of your finish coats, after a 72 hour interval for curing, these pieces can be safely waxed.

You can use wax shoe polish to achieve some interesting color effects atop the stains. Black on the ebony finish is quite handsome. Brown has quite an orange understain incorporated, so with your palette knife, mix a little black polish with a scoop of brown on a piece of foil or a little plastic lid. Grease it down with a soft paste wax before you buff; this wil' pick up any excess pigment from the shoe polish.

Acrylics can be handsomely 'aged' using the black and brown shoe polish mix, diluted with an equal part of paste wax, thoroughly blended.

Watercolor

The most successful means of tinting which best preserves the character of the wood grain and never obscures your carving techniques is to paint with transparent watercolor. Because the pigment is ground so extremely fine, and since water is such a mobile vehicle, it sinks into the pores of the wood. Mistakes cannot be over painted very successfully, but it can

very discreetly tone down distractingly strong contrasts in wood grain, and match woods where color differences are confusing.

It can be used only on raw wood where little or no patching was done with any type of filler. Transparent watercolor is the most responsive to the influence of the wood itself. The proper sealant causes the grain to bloom underneath the color by filling the vascularity with reflective resin.

This paint is sold in small tubes, like miniature tubes of oils or acrylics. It's best to test them on a scrap of wood from the project, because, like all water soluble paints, the colors may dry several shades lighter than they looked when applied.

Besides using them to reproduce an animal's color pattern, you can highlight your modeling by intensifying the shadows. Add another coat of your base color mixed with a small amount of a suitable dark color to naturally shadowed areas beneath muscle masses and joint edges.

The color may look a bit vapid and frosty until the proper sealant is applied.

Any coating which makes the piece water repellant can be used, but those which sink into the grain will be the most handsome. A high quality oil-resin made with petroleum distillates, so that it can be varnish compatible, is ideal. Any oil-base, turpentine soluble finish is going to yellow with age, but this characteristic enhances most wood and is predictable enough in some products to be used to artificially age a piece.

My preference from experience, is Watco Danish Oil Finish, natural color, for its super penetration and stability. It yellows least, but hardens in the tissue, making the wood stronger. My father was using this finish long before I started; on our early works it has mellowed well, impervious to extremes of heat, cold and humidity.

I follow the directions on the container, after a fashion; then over the course of several days, I'll soak the piece repeatedly to bring up the richest bloom in the grain under the paint. When the carving is mounted, it and the mount will get another dousing.

When dry and cured, this oil finish can be topped off with a coat of high quality satin-finish varnish if a more plastic surface is required. The varnish will yellow more than the oil finish.

Often a carving is made to look more substantial and handsome if it seems to have been around awhile. This is especially appealing on tinted carvings of animals.

A vintage finish, reminiscent of the turn-of-the-century heyday of those palatial 'rustic' lodges and cabins in the northeastern woods, is quickly and easily attained with several coats of Minwax Antique Oil Finish.

Monitor its drying closely after the first couple of coats because it will dry very shiny anywhere it collects on the surface. Blot all drips dangling on the undersides; they will dry, not fall off as will the more fluid Danish Oil. This finish is attractive immediately, but it mellows more quickly than others, so that in 10 years, a carving may have a patince that looks over 50 years old. It is especially suitable for the Bighorn, deer and moose carvings.

Water Color

For Black and White, use opaque water color, also called (Designer's) gouache (pronounced gwash), a higher quality, more stable version of that stuff that came in cakes or pans in the paintboxes you may have used as a schoolchild. Gouache is in tubes usually shorter and stouter than the tubes of transparent water color, for ease of identification.

Don't let your hobby shop tell you that no such thing exists; check instead with the bookstore serving a college art department, or the suppliers for commercial artists. This seems like quite a commotion over simple colors, but these will be so important that their

performance must be uniformly faultless.

Opaque Black	Hookers green
Opaque White	Raw Sienna
Transparent Cadmium Yellow	Burnt Sienna
Yellow Ochre	Burnt Umber
Alizarin Crimson	Raw Umber
(Grumbacher) red	Paynes Gray

Opaque blues mixed with white or green

Blues are better avoided in water color, because in this technique, considerable yellowing of the wood is expected. This turns blues into greenish colors, not too appealingly. If needed, mix gouache, or opaque water color, using blue mixed with some white or green.

Watercolor usually does not raise the grain of the wood, because it actually involves little water. On blade textured surfaces, the fibers have been sheared, so there's nothing much to be raised. Where you have sanded surfaces, you've probably finished up with such a fine grit abrasive that the wood fuzz was pretty well rubbed off.

Before painting, buff both kinds of surfaces with a clean toothbrush, or better yet, a fiber bristled brush in your flexshaft to burnish off all stray dust and fibers which could pop up in painting.

Should a patch pop up some fuzz after painting, buff it off with the brush mounted in the flexshaft, or give it a little rub with very fine wet-or-dry sandpaper, repainting if necessary. You can even safely sand and retint if an area gets to looking a little rough after several coats of your choice of sealer have dried on it.

Basic 'Mousegray' Recipe

This is the grizzled camoflage gray that is the foundation for many animal coats.

Raw sienna and white, with smaller amounts of raw umber and black.

In watercolor: Paynes gray, raw sienna and white

Basic Belly Buff

This is the pale tan on the undersides of many animals.

White, with a small amount of raw umber, and burnt sienna

In every instance, check the proportions of the colors on a scrap of wood ahead of time, so that amounts can be adjusted as needed.

Cougar:

To the 'mouse' recipe, add yellow ochre. A small amount of burnt sienna can be blended into the back and top of the tail in some individuals.

Mix more white into 'buff' for a creamy near-white for muzzle, under jaws, down the neck and chest, insides of forearms and thighs, lower paws. This also goes inside ears and beneath eyes.

Burnt umber and black are for the facial markings and backs of ears.

The nose is pink: cadmium red and white.

Eyes are burnt sienna.

Rabbit:

Into the 'mouse' recipe, mix a little burnt sienna at the nape of the neck, shoulders and ribs, as well as on the 'wrists' and outsides of the feet.

Use buff mixture on the rabbit's underneath; pure white on his tail.

The insides of his ears are 'flesh' colored; white with a small amount of cadmium red and raw sienna. The outsides are the same color as the body hair, with slightly darkened tips and edges (burnt umber).

Use burnt umber for the eyes.

Jackrabbits are a very pale sandy tan when found in arid regions, so add more white and a touch more raw sienna to the basic 'mouse' color. Their undersides are nearly white. There is a small dark gray patch on the top of the tail.

Wolf:

To the 'mouse' recipe, add more white, or burnt umber or black. On gray wolves, mix in burnt sienna on the top of the muzzle, and outsides of forearms and thighs. Add more white to the buff for their undersides.

Noses and lips are black.

The tongue and gums are alizarin crimson and white mixed with a tiny bit of cadmium red.

Eyes are raw sienna and cadmium yellow, or burnt sienna.

Pointer:

These dogs are white, spotted usually with burnt sienna, burnt umber, raw umber or black.

To keep your white undercoat from looking chalky, pollute it with a dab of raw sienna, adding a little cadmium red to work into the muzzle, underarms, belly and in between the hams, where the hair is thinnest.

All-white dogs, and those with lighter brown spots have light noses; burnt sienna and white, instead of black. The pads of their feet are similar to their noses. Their eyes are nearly the color of their spots.

Bighorn:

Mountain sheep come in several color patterns, but the models, in Yellowstone Park, were a warm tan; mouse gray with burnt umber added. They had pale buff muzzles and eye patches, circular rump patches, chests and bellies. There was also a pale buff stripe the length of the back of each leg.

Their faces were smoky dark; burnt umber that spread like a bib down the front of the neck and extended in a small mane, nearly to the shoulders in back. From the forearms and thighs down to the hooves on the fronts of the legs was burnt umber, as was also the tail.

Hooves and dewclaws were burnt umber darkened with a little black.

Horns were the mouse mixture including some yellow ochre in the mix, with a little raw umber staining the front edges.

Whitetail buck:

One of the most attractive color phases is burnt sienna toned down a bit by including a little of the 'mouse' mixture. It is brightest along the back of the neck and shoulders, down the back and over the hips, including the topside of the tail. It fades (mix in more 'mouse') on the underside of the neck, shoulders, ribs, flanks and legs.

A WOODCARVER'S WORKBOOK

Use buff on the underside, from behind the forelegs on toward the hams, on the insides and backs of the lower legs from the knees and hocks down to just above the dewclaws.

Add more white to lighten the buff for the throat patch underneath the jaws, around the eyes, inside the ears, on the muzzle. Save the pure white for the back of his flag and in between his hams.

Burnt umber and an equal amount of black go on the edges of the ears, the muzzle bar and front tip of the tail. Add more black for hooves, dewclaws, nose and lips.

Eyes are burnt sienna or burnt umber.

Start up the beams of his rack with a mix of raw umber and white, adding more white as you head for the polished tines.

Unicorn and Horse:

Traditionally unicorns were white, though whether they were albino, or gray that whitened with age was not included in the legend.

Albinos have pink skin showing where the hair is thinnest; on their muzzles, around their eyes and bases of ears, underarms and bellies. Their eyes are pale blue, called 'glass' eyes on account of their rather zany stare. Their hooves are pinkish tan; white with a little burnt sienna.

Aged gray, as in Lippizaners for example, have white hair over dark skin, so there may be a hint of smoky, pearl gray around the muzzle, eyes, inside the ears, underarms and bellies. There may be a hint of the same pale gray on knees and hocks.

The edges of the eyelids and nostrils may be dark gray, and the hooves are nearly black. In watercolor, this can be done in Paynes gray.

They have dark eyes, burnt sienna or burnt umber.

The choice is yours.

Your mustang can be any domestic horse color, though in the wild, black, gray, various shades of brown and buckskin predominate.

Buckskin is a wonderfully wild color; thinned yellow ochre or raw sienna, perhaps faded by the addition of some white. The mane, tail and lower legs, from knees and hocks down to hooves are very dark brown, nearly black; use burnt umber and black mixed. The edges and tips of the ears are trimmed in this color, as is the muzzle, or in some individuals, the whole face. Down their backbones, buckskins have a characteristic dark stripe connecting mane and tail; there are occasionally little dark stripes on the backs of the knees and around the hocks as well.

Their eyes are dark, burnt umber. Their hooves are black.

Paynes gray, either diluted or straight, is stunning for every shade of gray from fleabitten to steeldust.

Burnt sienna makes a beautiful bay; for a dark bay, use burnt umber. Bay horses have black trim; manes, tails, muzzles, ear edges, lower legs. They often will have a white star or thin blaze on their faces, and may have one or more white socks.

Hooves at the bottom of dark legs are black; hooves below white markings are light, burnt sienna and white. Bays often have buff bellies.

The Cheyanne Indians treasured a rare color pattern they called 'Medicine Hat', a white horse sparsely marked with red (burnt sienna). The esteemed 'war bonnet' was an irregular red patch over the poll underneath the white forelock, and including both ears. It was also splashed down the throat, sprinkled along the back, ending in a patch on the rump, on the backs of the hams. There may be a few red speckles on the lower ribs, sometimes on the backs of the forearms. The mane and tail are white.

Moose:

Burnt umber is an excellent base for the moose. There is a cape of slightly lighter hair over the upper part of the shoulder hump and back of the neck; mix burnt umber into the 'mouse' base until you have an uneven sandy brown. Leave a dark stripe down the vertebrae. Use this mix on the muzzle around the nostrils and lips, and inside the ears.

Add a little black to the burnt umber on the bell, lower neck and chest, upper forearms and thighs. The fronts of the lower legs are this dark mixture.

For the insides of the forearms and thighs, and backs of the lower legs, mix more white and a little black into the 'mouse' gray.

Hooves and dewclaws are nearly black with only the slightest burnt umber cast.

The eyes also are very dark, burnt umber and black, showing a murky sclera of burnt sienna and white in the front and back corners.

On the antlers, use white with a little raw umber; darker on the rougher beam and palmate portions, lighter on the polished tines.

A WOODCARVER'S WORKBOOK

BASES

Just when you thought you were finished, it's time to give serious thought to mounting your completed carving on a suitable base. Be prepared to spend almost as much time and effort as you did the piece itself, on engineering the appropriate display for it. The pains you take make a powerful statement about the importance of the figure, and have quite an impact on your audience.

First, you need a surface on which to secure your carving, for reasons of safety as well as aesthetics. Poplar is a good choice, being fairly strong, yet not too heavy, readily available and comparatively inexpensive. Three different trees are marketed as poplar, so the character of individual boards varies interestingly. Look for the ones uneven in color; sapwood inclusion may be olive green to earthy brown. This will suggest the irregularities of the ground handsomely for wildlife carvings. Poplar stains very well with transparent watercolor.

Raised bases make fitting presentations of your carvings. The height may be only the thickness of the lumber from which you cut and polished a simple quadralateral, oval or freeform. Smooth, polished surfaces, whether natural or stained, are formal settings for serious pieces, such as the pointer when used as an award or trophy. Polished bases are also suitable for fantasy figures, the unicorn or stylized buck for example. Smooth surfaces make a nice textural contrast to carvings mounted on weathered wood, like the cougar balanced on a windfall.

If you have cabinetmaking experience and equipment you might shape a fancy molding on the edge of the base with a router or lathe, on the heavier round base. Check the craft supplies in your area, even at the large discount stores; occasionally they will have pine plaques with routed moldings, intended for decoupage or tole painting, that make handy bases for carvings.

The majority of animal figures look best on textured bases simulating non-specific trampled vegetation, earth or rock.

Gently trace around the feet of the carving posed on the base lumber; it's best not disturb the full contact of the footprint area. Use your largest gouge to start covering the ground with brief cuts, generally following the direction implied by the figure. Make the surface pretty rugged; it will give the illusion of a depth greater than ¾ inch. Don't neglect the edges, which should be equally craggy, neither uniform in depth nor in slope. Some places should be reduced to ¼ inch thickness.

After the rough contours have been fixed, return to give them little irregular nips with your smallest gouge, deepening the shadows in the bottoms of the larger gouge facets. Guard, though, against strokes that are too much alike, too even or regular, or that inadvertently form a pattern. This distracts attention from the focus—your critter!

Don't hesitate to build landforms as needed, either by laminating or by cabinetmaking techniques so that you get height without weight. A basic box form can be carved into an excellent rocky ledge for the cougar, howling wolf or bighorns.

Higher bases give your work a monumental significance. The base level can be raised by the addition of another layer of wood underneath, possibly of a contrasting color. A very dramatic, raised base can be constructed from moldings; flush picture framing, with square outside edges, makes wonderful bases. Stood on edge, the molding forms the plinth, while the rabbeting on its inside edge is a little shelf supporting the wood base to which the figure is fastened.

Bases~ *Smooth, polished, simple shapes are more formal.*

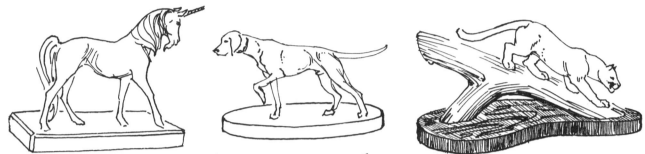

Stain with watercolor before mounting the piece or sealing. Alizarin Crimson for the unicorn is a rich ruby to burgundy; Paynes gray recalls moonlight and shadows; Hookers green is mossy, outdoorsy for the Pointer. A nicely figured piece of walnut is a handsome foil for a weathered branch.

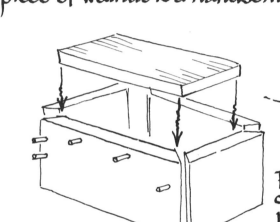

'Weathered Rock' is a box with mitered edges and an inset top to reduce end grain, which finishes irregularly. Drill through longsides, peg, as well as glue.

For added naturalism, saw off an angled portion of bottom edge. Texture ruggedly to simulate rock. Remember to include the top. Paynes gray is an excellent color to stain rock. Weathered rock ledges should be mounted on a smooth shaped base, or a textured raised base. Along with glue fastening the 'rock' to its base, 2 screws through the underside of the base into opposite sides of the 'rock' are needed for security.

Textured Bases *are especially effective for wildlife carvings.*

Remember to make edges interesting.

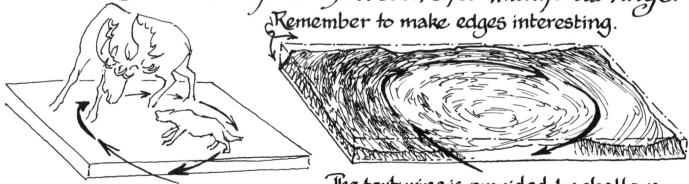

All of the gouge texturing is very directional; following and reinforcing the focus of the carving.

The texturing is provided by shallow gouge cuts (fishtail gouge) interspersed with random clusters of strokes with the smallest gouge for variety.

Picture frame molding may be available through a local gallery or professional framer, though usually they prefer to sell only an unweildy great length of molding by the uncut piece. A good source of moldings in convenient lengths of 4 feet or more is listed in the appended sources.

Unless you've already got cabinetmaking equipment that will make the precisely angled cuts, you will need to acquire an inexpensive miter box and back saw.

To insure the best fit, make the first angled cut on the end of the molding strip, then prop the base on top of it, in position. Make sure that molding and base corners match absolutely exactly, then mark the location of the opposite corner on the molding. Number the rascal on the back, and don't forget to swap angles on the miter box before you begin to cut.

Swap angles and cut the leading end of the molding to form the second corner. Position the first side under the base, then slip the second into place, butting the corners most carefully. Mark the third corner.

By cutting and fitting each successive side and corresponding corners, you'll insure a snug mount. Take the bench knife and trim off any little splinters on the ends of each piece of molding.

Be sure to do a dry run, assembling all four sides with the base in place on top to check for an accurate fit before you glue. Spread a precautionary piece of plastic over a very level surface big enough to support this whole piece through glueing and drying. You may have had other experiences in joinery, so do as you know best. Fastening with aliphatic resin (yellow carpenters glue) has proven entirely satisfactory during handling, enduring extremes of temperature and changes of humidity as well as standing up to the rigors of shipping.

Apply glue generously to both surfaces of each corner joint, glueing up all four corners. Follow immediately with a good bead of glue on the shelflike projection of the rabbet. Position the carved base in this at once, checking the corners of the molding for alignment. Quickly wipe up any major dribbles, then apply clamps.

There are available framing clamps connected by adjustable threaded rods for securing quadralaterals with right-angled corners, perfect for securing the molding while the glue dries. However, a satisfactory substitute is to use the very large rubber bands available from office supply stores for bundling bulk mailings. Several of the 12 inch ones snugged around the molding, top and bottom, will really do the trick, though they can be a bit wild to install unless you're equipped with an extra pair of hands.

Check again for alignment, and clean up any drips with a paper towel lightly moistened with water.

When the glue is dry, and has had at least overnight to cure, remove the clamps and prepare to finish the molding corners. Mix a little raw umber and black acrylic paint and brush it generously on all four corners. By the time you've worked the paint well into the last corner, the first corner probably will be ready to wipe. Fold a dry paper towel over your fingertip and wipe up excess pigment until the joint is hidden and the corners look almost imperceptibly 'antiqued.' This usually needs no sealer.

The base supporting your carving needs now to be saturated with a finish compatible with the figure and molding. Oil based finishes, like varnish or oil-resin finishes are safe choices.

Title labels on the bases are a fine way to complete your presentation. Metal labels can be ordered through a trophy company or sporting goods store. Because these are intended for mounting on plaques and awards, so will look just like a trophy. Unless you have a jeweler friend who will engrave a custom plate for you, you may never have labeled a base because the trophy label did not appeal to you.

To mount your carving on its base, check its location and carefully trace with pencil around each contact point (feet, tail, etc.). Figures with a relatively low center of gravity will need to be pegged in two places, on opposite sides (check pegging technique at the end of the cougar chapter); rearing figures need three pegs. Miniatures are pinned with brass wire. When pegs are in place in the carving, stand it on the base and trace around the pegs so you can drill accurately. Do a 'dry run' to check fit before gluing each contact as well as the pegs with carpenters glue. Clean up all drips immediately.

A Raised Base is a fine stage for your work.

Picture frame molding with an outside edge thicker than the rabbeted inner edge is best.

Check the source list etc.

Make the first mitered cut. Draw, then saw the 2nd.

Saw the 3rd corner; position side #1, butt corners 2 and 3, draw corner 4. Saw that corner, and repeat the procedure. Fit each side with the mounted carving in place.

Usually carpenters glue alone, applied to both sides of each joint, as well as in the rabbet groove to hold the mounted carving, is secure enough. If your mounting is especially complex or heavy, glue extra support blocks in each corner on the underside of the base.

M.D.Guldan
1987

Test your sealer on a scrap of frame; Danish oil and varnish based finishes are usually compatible. By sealing the base AFTER gluing, you get a better glue joint on raw wood, now protected from changes in atmospheric humidity.

While we're down here, sign and date your work on the underside of the base, in pencil, which ages best.

Put your 'John Hancock' on the antiques of tomorrow!

If you or a helpful friend has ever done any lettering with a steel-nibbed dip type pen for caligraphy, you can make your own labels. Consider these possibilities.

Where heavy gauge brass sheet-stock is available, you can saw out your own designed blanks with a jeweler's saw (mounted with a fine blade). Punch a couple of mounting holes in the ends and finish the rough edges with a file. Clean and polish meticulously with fine steel wool, being careful not to contaminate the top surface with fingerprints. Spray lightly with lacquer.

It may be more convenient to saw the blank out of a piece of wood. Unused tongue depressors or popsicle sticks are good quality basswood; cut off the rounded ends, bevel the edges or grind an ornamental shape with abrasives in your flexshaft. Drill little mounting holes in either end.

Paint the blank gold with water soluble tempera or acrylic paint. Most craft gold paints have a toluene base which can be a hazard to other finishes. The ideal is a gold tempera, dry, in small pans, by Pelikan, available through art supply stores. More easily found is gold acrylic in tubes, but it is rather vague and pale, and needs to have a little extra gold-colored bronzing powder mixed in.

When the blank is completely dry, seal it with a light coat of lacquer.

You can make your own gilt paint by mixing bronzing powder with quality varnish. It will naturally darken with age, but is still handsome. Just don't spray lacquer on it, the two finishes are not compatible.

When your wooden or metal title blank is dry, trace its outline several times on a piece of paper. Rule guide lines on the paper samples and practice fitting your title and name, first in pencil, then in ink.

Place your metal or wooden blank beneath the most successful practice one, so that you will be able to keep a constant eye on the size and spacing of your letters. A soft lead pencil used very gently on the blank usually will do no harm and is extremely useful in planning. You will ink right on top of it so that it won't show.

Use a steel pointed pen which you dip into ink; a small broad nibbed penpoint for calligraphy is best. The ink should be waterproof black india ink meant for drawing on plastic film as well as paper, so it will not crawl or bead on nonporous surfaces.

Letter your title and name onto the metal or wooden plate, and let it dry thoroughly before sealing it with a protective coat or two of lacquer.

If you make a mistake, scrape or sand it off and have another go at it.

Fasten the finished plate to your base with glue and brass escutcheon pins.

Finally, sign your work legibly, in soft lead pencil, on the underside of the base, including the date, and if the space possibly allows, your location. Lead pencil is the most enduring writing implement, and the underside of the base is the spot least likely to suffer the ravages of time and grime.

While you may not consider this your 'magnum opus,' it is your work and your signature is of the utmost importance.

First, this identification is vital from the economic standpoint; your name, date and address will be the exciting and authentic provenance, or 'pedigree,' for future collectors. While you may never seek national reknown for your creative endeavors, your signature will probably be worth money several generations from now. Currently, signed pieces of Americana by otherwise unknown artists are commanding prices up to 1/3 higher than unsigned works that may even be of slightly superior quality. This is likely to continue, as the public becomes increasingly aware of its growing disillusionment with the Industrial Revolution, and the sterility and the occasional shoddiness of mass production.

The second reason for signing your work is that there is a deep psychological appeal in your handwritten name, acquiescing to that most basic recognition of the common bond of humanity, despite the intervention of time and distance. People delight in recognizing the kindred spirit in each other. Your signature says that you liked your work; its new owners will share your enthusiasm.

Your carving is likely to become a cherished relic of those ephemeral 'good old days' to nostalgic collectors in the coming century. They will ponder your signature and probably picture you as a resourceful and vigorous near-pioneer. They will wonder about your other carvings.

What an inviting way to make your mark upon the future.

Pick up your pencil and sign that rascal! Then, you'd better get started on another carving.

BACKWARD?

There IS something to be said for mistakes....
other than ~ or

Grrrr!!!

Mistakes are learning experiences.

At least, you learned what does not work!

I've learned that quite a lot.

Some carving mistakes can be remedied by sawing off the error and attaching a new piece of wood. Refer to the mending lesson in the Cougar chapter, because most replacements need to be pegged for stability.

Oh woe!

Awww!

Don't forget that the wood putty compounds popularized by the duck decoy carvers can hide some errors. Paint can mask a variety of patches; dark stains can cover unsuccessful paint jobs.

Be realistic in your assessment. A creative and inquiring mind is never going to be completely satisfied with any project, and will always see needs for change or improvement. A veteran teacher startled our faculty with the adage "The day you quit learning new things is the day you die."

The same is true of artwork. When you produce that Perfect Piece, your creativity just expired.

For most of us, Perfect Pieces are no threat. There's so much to learn, it's going to take a busy lifetime just to get a toe hold.
Move over, Methuselah!

You are invited to Join the

National Wood Carvers Association

" Some carve their careers: others just chisel"
<u>since 1953</u>

If you have any interest in woodcarving: if you carve wood , create wood sculpture or even just whittle in your spare time , you will enjoy your membership in the National Wood Carvers Association. The non-profit NWCA is the world's largest carving club with over 33,000 members. There are NWCA members in more than 56 countries around the globe.

The Association's goals are to:

* promote wood carving
* foster fellowship among member enthusiasts
* encourage exhibitions and area get togethers
* list sources of equipment and information for the wood carving artist
* provide a forum for carving artists

The NWCA serves as a valuable network of tips, hints and helpful information for the wood carver. Membership is only $8.00 per year.

Members receive the magazine "Chip Chats" six times a year, free with their membership. "Chip Chats" contains articles, news events, demonstrations of technique, patterns and a full color section showcasing examples of fine craftsmanship. Through this magazine you will be kept up to date on shows and workshops to attend, new products , special offers to NWCA members and other members' activities in you area and around the world.

National Wood Carvers Association
7424 Miami Ave.,
Cincinnati, Ohio 45243

Name:_____

Address:_____

Dues $8.00 per year in USA , $10.00 per year foreign (payable in US Funds)

My father claims that I am mostly self-taught; because he's a gallant gentleman wanting to spare somebody the blame, but by golly, I'm going to pass the buck myself!

My art education started very early, with innumerable museum visits and all the finest art books my parents brought from the library weekly. I have never recovered from the allure of Riemenschneider saints and Tang dynasty funerary horses.

We always had all kinds of art supplies. When my mother's friends protested the wisdom of turning a preschooler loose armed with her own stapler and a pound of staples— "That baby will hurt herself!" "She'll staple her fingers!" "Once," replied my mother, and set a place at table for the life-size yearling heifer I stapled out of wastepaper from Daddy's office.

I spent hours at Daddy's elbow, watching him carve architectural ornament for the furniture and house he had built. When my nose cleared the edge of his workbench, he taught me to carve.

The formal art training began before I was in 1st grade, to the instructor's dismay. She thought I was too young; I had to be escorted downtown by a worldly 8 year old, who could read the destinations on city buses, but most important, could reach the elevator buttons to get us up to our classes. It was the start of many years of courses, of watching, working and learning from many very creative and gifted artists who shared the wealth of life times of experience in a terrific variety of disciplines.

I was especially fortunate to be taught by William Wheeler, author of the definitive Practical Woodcarving and Gilding, at The City and Guilds of London Art School, shortly before his retirement. Mr. Wheeler, with spare, but good humored precision, gave a dignified credibility to woodcarving as an all purpose sculptural as well as decorative medium rather than dismissing it as the preservation of a quaint but fading craft.

My work, in various mediums, has won many awards in competition, and is included in collections both in the U.S. and abroad. Most of my best efforts have gone into years of teaching.

In the end it's not the prestigious prizes that really matter, but who you've helped along the way. So, take what you found here, add to it from the wealth of your own experience— and pass it on!

Take a Look at Our Other Fine Woodworking Books

Woodcarving Books by George Lehman
Learn new techniques as you carve these projects designed by professional artists and carver George Lehman. These best-selling books by a master carver are invaluable reference books, PLUS each book contains over 20 ready-to-use patterns.

Book One - Carving Realistic Game and Songbirds - Patterns and instructions
Enthusiastically received by carvers across the US and Canada. George pays particular attention to the needs of beginning carvers in this volume. 20 patterns, over 70 photos, sketches and reference drawing.
ISBN# 1-56523-004-3 96 pages, spiral bound, 14 x 11 inches, includes index, resources $19.95

Book Two - Realism in Wood - 22 projects, detailed patterns and instructions
This volume features a selection of patterns for shorebirds and birds of prey in addition to all-new duck and songbird patterns. Special sections on adding detail, burning.
ISBN# 1-56523-005-1, 112 pages, spiral bound, 14 x 11 inches, includes index, resources $19.95

Book Three - Nature in Wood - patterns for carving 21 smaller birds and 8 wild animals
Focuses on songbirds and small game birds . Numerous tips and techniques throughout including instruction on necessary skills for creating downy feather details and realistic wings. Wonderful section on wild animal carvings with measured patterns.
ISBN #1-56523-006-X 128 pages, soft bound, 11 x 8.5 inches, includes index, resources $16.95

Book Four - Carving Wildlife in Wood- 20 Exciting Projects
Here is George's newest book for decorative woodcarvers with never-before-published patterns. Tremendously detailed, these patterns appeal to carvers at all skill levels. Patterns for birds of prey, ducks, wild turkey, shorebirds and more! Great addition to any carvers library - will be used again and again.
ISBN #1-56523-007-8 96 pages, spiral-bound, 14 x 11 inches, includes index, resources $19.95

Easy to Make Wooden Inlay Projects: Intarsia by Judy Gale Roberts
Intarsia is a method of making picture mosaics in wood, using a combination of wood grains and colors. The techniques and step-by-step instructions in this book will have you completing your own beautiful pieces in short order. Written by acknowledged expert Judy Gale Roberts, who has her own studio and publishes the Intarsia Times newsletter, produces videos, gives seminars and writes articles on the Intarsia method. Each project is featured in full color and this well written, heavily illustrated features over 100 photographs and includes index and directory of suppliers
ISBN# 56523-023-X 250 pages, soft cover, 8.5 x 11 inches $19.95

Two more great scroll saw books by Judy Gale Roberts! Scroll Saw Fretwork Patterns
Especially designed for the scroll saw enthusiast who wishes to excel, the 'fine line design' method helps you to control drift error found with thick line patterns. Each book features great designs, expert tips, and patterns on oversized (up to 11" x 17"!) sheets in a special "lay flat" spiral binding. Choose the original Design Book 1 with animal and fun designs, or Design Book Two featuring "Western- Southwestern" designs.
Scroll Saw Fretwork Pattern, Design Book One "The Original" $14.95
Scroll Saw Fretwork Patterns, Design Book Two "Western-Southwestern" $16.95

Scroll Saw Woodcrafting Magic! Complete Pattern and How-to Manual by Joanne Lockwood
Includes complete patterns drawn to scale. You will be amazed at how easy it is to make these beautiful projects when you follow Joanne's helpful tips and work from these clear, precise patterns. Never-before-published patterns for original and creative toys, jewelry, and gifts. Never used a scroll saw? The tutorials in this book will get you started quickly. Experienced scroll-sawers will delight in these all-new, unique projects, perfect for craft sales and gift-giving. Written by Joanne Lockwood, owner of Three Bears Studio in California and the president of the Sacramento Area Woodworkers; she is frequently featured in national woodwork and craft magazines.
ISBN# 1-56523-024-8 180 pages, soft cover, 8.5 x 11 inches $14.95

Making Signs in Wood with Your Router by Paul Merrills
I f you own a router, you can produce beautiful personalized signs and designs easily and inexpensively. This is the complete manual for beginners and professionals. Features over 100 clear photos, easy-to-follow instructions, ready-to-use designs, and six complete sign making alphabets. Techniques range from small nameplates to world-class showpieces trimmed with gold leaf.
ISBN# 56523-026-4 250 pages, 8.5 x 11 inches; includes index and suppliers directory $19.95

- -

To order: If you can't find these at your favorite bookseller you may order direct from the publisher at the prices listed above plus $2.00 per book shipping.
Send check or money order to:

Fox Chapel Publishing
Box 7948D
Lancaster, Pennsylvania , 17604